Lucy Gent

Picture and Poetry
1560 ~ 1620

*Relations between literature and the visual arts
in the English Renaissance*

'. . .the truest poetry is the most feigning'
As You Like It, II. 3. 22

James Hall
Leamington Spa
1981

Published by **James Hall (Publishing) Limited,** 2a Upper Grove Street, Leamington Spa, Warwickshire CV32 5AN, Great Britain

Filmset in Times New Roman 10 on 11 point by Typesetting & Graphics, Leamington Spa. Printed and bound in Great Britain by Billing and Sons Limited, Guildford, London, Oxford, Worcester

British Library Cataloguing in Publication Data

Gent, Lucy
 Picture and poetry 1560-1620.
 1. Art and literature – England
 2. Art, Renaissance – High Renaissance – England
 3. English literature – Early modern, 1500-1700 – History and criticism
 I. Title
 700′.942 PN53

ISBN 0-907471-00-5

Contents

Acknowledgements

I SHOULD like to thank the following who read the whole or some part of this book in draft, and who made many helpful suggestions: Michael Kauffmann, Peter Meade, Moira Megaw, Sir John Summerson and Professor J.B. Trapp. Particular thanks go to my husband, Malcolm Turner, for both reading the work in all its various drafts, and generously funding a year's unpaid leave in 1974-75. That year's work might well have been abandoned permanently save for the well-considered remark of the late John Speirs, who pointed out that it could yet prove the basis of further developments; as turned out to be the case. A term's study-leave from my employers, the Polytechnic of North London, enabled me in 1979 to write the essay in its present form.

I am grateful to Miss E.G. Mackenzie for continuing encouragement. John Fuggles, Alastair Moffat, and Julian Roberts have been most helpful over particular problems.

My thanks also go to the many librarians and individuals who have answered queries and assisted me: Mr J.P. Brooke-Little, Professor B.A.R. Carter, Mr R.H. Harcourt-Williams, Mr Paul Morgan, Mr Howard Nixon, Dr D.M. Rees, Dr David Rogers, Dr D. Smail, the late Mr Francis Steer, Sir Anthony Wagner; and the staffs of the British Library, the Bodleian Library and Lambeth Palace Library. Mr and Mrs Edmund Brudenell hospitably showed me the library at Deene Park.

Robin Lister of James Hall has been a most positive and tactful literary editor to whom I owe many thanks.

Photographs are reproduced by kind permission of the Tate Gallery (Plate 1), the Trustees of the National Gallery, London (Plate 2), the Victoria and Albert Museum (Plate 3), the Trustees of the British Museum (Plate 4), and Lambeth Palace Library (Plate 5).

Chapter I

IN any age the relation between the various arts is intriguing. When poets speak about pictures in their poetry their accounts often have an air of significance, and the reader is thus led on to ask questions such as what painting the writer has in mind, how much he knows about paintings, and why he bothers to turn aside from the usual subject-matter of literature to describe another art.[1] English literature of the late sixteenth and early seventeenth centuries is a particularly alluring siren in the matter of pictures and poetry, because it so often appeals to visual appearances, and moreover to visual appearances in the shape of pictures.[2] Poets describe what seem to be real pictures, such as the 'skilful piece of painted work' in Shakespeare's *Lucrece*, or the landscapes in Drayton's *Mortimeriados*. Allusions to pictures are constantly turning up, whether in the prose of writers such as Lyly and Sidney, or in the sonnet sequences, so liberally interspersed with references to portraits of the poet's mistress, or in the plays of, say, Lyly, Shakespeare, and Webster. References to pictures litter the puffs and prefaces of the period. Not unnaturally, the reader begins to think that pictures are in some way influencing the writers.

The snag is that the obvious clues in the literature do not lead to actual pictures, or at least to any that have survived;[3] the poets' descriptions cannot be related to their pictorial counterparts. Furthermore, the poets praise a degree of artistry in their pictures which it turns out to be impossible to match in the works of art they had around them. Marlowe in *Hero and Leander* (1592) suggests bold, daring and

[1]The extensive literature on the subject of poetry and painting includes: J. Hagstrum, *The Sister Arts: the Tradition of Literary Pictorialism and English Poetry from Dryden to Gray* (Chicago, 1958); R.W. Lee, 'Ut pictura poesis: the Humanistic Theory of Painting', *Art Bulletin*, 22 (1940), 197-269; M. Praz, *Mnemosyne, the Parallel Between Literature and the Visual Arts* (London, 1970). On the relation between word and visual image, M. Baxandall's *Giotto and the Orators* (Oxford, 1971), has been very helpful in the present study. [2]Studies on pictures and poetry in England in the late sixteenth and early seventeenth centuries include: J. Buxton, *Elizabethan Taste* (London, 1963); R. Strong, *The English Icon* (London, 1969); D.J. Gordon, *The Renaissance Imagination* (Berkeley and London, 1975); L. Salerno, 'Seventeenth-Century English Literature on Painting', *JWCI*, 14 (1951), 234-58; D. Chambers, '"A Speaking Picture": Some Ways of Proceeding in Literature and the Fine Arts in the Late Sixteenth and Early Seventeenth Centuries', in *Encounters*, edited by J.D. Hunt (London, 1971), pp. 28-57. [3]There is perhaps one exception: Katherine Duncan-Jones has very recently argued that Sidney in one description refers to a particular painting by Titian; see 'Sidney and Titian', in *English Renaissance Studies Presented to Dame Helen Gardner*, edited by J. Carey (Oxford, 1980), pp.1-11.

realistic paintings of 'Love kindling fires, to burne such townes as Troy', possessing a brilliance to match his own virtuosity:

> . . . Danaes statue in a brazen tower,
> Jove slylie stealing from his sisters bed,
> To dallie with Idalian Ganimed.[4]

When one looks for mythological paintings of the period in England, one has to be satisfied with the ebullient but scarcely sophisticated 1621 wall-paintings at Bolsover Castle.[5] Elizabethan descriptions of pictures and statues, which so often expatiate on the artist's mastery, may remind a modern reader of the achievements of the Italian Renaissance — as in the strange statues mysteriously animated, in Chapman's *Ovids Banquet of Sence* (1595):

> To these dead forms, came living beauties essence
> Able to make them startle with her presence.[6]

We are invited, in terms of painting, to expect the hand of a Titian; what we find are at best pale echoes of the school of Raphael — as in such of the Hill Hall paintings as survive[7] — or the highly distinctive English genius of a Gower or a Segar portrait that seems so remote from French or Italian art. And when Spenser says that the pictures of the *Shepheardes Calender* (1579) are 'so singularly set forth, and purtrayed, as if *Michael Angelo* were there, he could (I think) nor amende the best, nor reprehende the worst', it is hard to remember that he is referring to the woodcut illustrations familiar to us from the Oxford Standard Authors reproductions, rather than another and more virtuoso set.[8]

One quickly discovers that the writers formed part of a patronage system that, so far as painting was concerned, was limited and unenlightened, and in which a vicious circle operated. For, according to Haydocke, the buyer would refuse 'to bestowe anie great price on a peece of worke, because hee thinkes it is not well done', and the painter would reply 'that he therefore neither useth all his skill, nor taketh all the paines that he could, because hee knoweth beforehand the slendernes of his reward'.[9] Most Englishmen were not interested in

[4]Sestiad I 146. All quotations from *Hero and Leander* are from *Elizabethan Minor Epics*, edited by E.S. Donno (London, 1963). [5]Illustrated in E. Croft-Murray, *Decorative Painting in England 1537-1837*, 2 vols (London, 1962 and 1970), I, Plates 52-57. [6]*The Poems of George Chapman*, edited by P. Bartlett (New York and London, 1941), p.54, stanza 6. [7]Illustrated in Croft-Murray, *Decorative Painting*, I, Plate 39; see also pp.28, 185. [8]*Spenser: Poetical Works*, edited by J.C. Smith and E. de Selincourt (Oxford, 1912), p.612. [9]Richard Haydocke's preface to *A tracte containinge the artes of curious painting carvinge & buildinge* (Oxford, 1598), his translation of Lomazzo's *Trattato dell'arte de la pittura* (Milan, 1584), sig. ¶ v^{r-v}.

paying out for pictures. In France can be found the Canon of Poitiers who towards 1581 owned, apart from four paintings based on the Old and New Testaments, as many as twenty landscapes, a reclining Venus, a disarming of Mars, two paintings of Lucrece and one of Ceres, paintings of Actaeon, Midas, the Centaurs and Lapiths, Hercules and other subjects.[10] No comparable middle-class inventory can be found in England; in fact, the sort of English inventory that can be put side by side with the Canon's is that of an anonymous professional Englishman, well-to-do and well-read to judge from his books, whose pictures in 1595 amounted to his own portrait, a picture of the passion of Christ, 'An Emblem of Love' and 'Quen an bullayne'.[11] The meagreness of his pictures is emblematic of the reluctance of English society — to which, after all, the writers belonged — to provide any but meagre patronage.

Frustrated in an attempt to find real pictorial sources, one is then tempted to attribute all apparent interest in pictures to literary sources: to rhetorical and ekphrastic tradition, to the widespread doctrine of *ut pictura poesis*, and to the discourse of influential classical authors, such as Pliny and Plutarch, on pictures. Yet a state of affairs in which the poets took all their pictorial allusions from books is surely as unlikely as the other extreme which suggests that the poets stood in front of pictures, as it were, and wrote down what they saw. In a period when visual experience was highly valued — as it was in the late sixteenth century — the experience of visual works of art was likely to contribute something to literature.

Although I have no startling new evidence about actual paintings seen by English poets, I shall be arguing that the way they looked at pictures influenced, in some respects, the way they wrote their poetry.[12] For, while in general disposed to believe that the loves of picture and poetry 'so truly *Paralel,*/Though infinite can never meet', I am led by the evidence to think that there was a bridge between the two arts in England at the end of the sixteenth century; and that the experience of seeing pictures contributed to the creation of the impressive verbal display we associate with the Elizabethans. It is a tricky point to establish, because no one can finally determine whether what writers say about pictures is influenced by the pictures they actually saw, or by the patterns, options and vocabulary offered them by their language. To take a very simple example, does John

[10]See J. Plattard 'La. . . Collection de Tableaux d'un Chanoine de Poitiers', *Revue du 16ᵉ siècle*, 7 (1920), 252-55. [11]'An inventory of my books 1594, Feb. 14', Oxford, Bodleian Library, MS Rawlinson D. 213, fol. 6ʳ. [12]Inventories of paintings are listed in Strong, *The English Icon*, p.43. They have been thoroughly discussed in relation to Sidney by Katherine Duncan-Jones, 'Sidney's Pictorial Imagination' (unpublished B. Litt. thesis, University of Oxford, 1964); and in relation to landscape by H.V.S. and Margaret S. Ogden, *English Taste in Landscape in the Seventeenth Century* (Ann Arbor, 1955), ch.3. See also Buxton, *Elizabethan Taste*, ch.3.

Weever call the effigy of Sir William Weston in the Priory Church of St John in Camberwell 'the most artificially cut that ever man beheld' because he has never seen a more skilfully executed and accurate piece of sculpture?[13] Or is he simply using a verbal formula that leads him to describe the sculpture in a particular way? The fact that in this case the piece of sculpture survives, and is mediocre, only highlights the problem. I hope to show that, even when allowance has been made for the influence of pre-established patterns of language, which in literature takes the special form of ekphrasis, in the Renaissance period in England, at any rate, the influence was from pictures to poetry.

On the surface the obvious way of exploring the relationship might seem to be to start from what the writers say about individual pictures (or sculptures) and thence to search for corresponding objects. Thus, some sixty years ago Sidney Colvin discussed various possible pictorial models for the Troy-painting in *Lucrece*.[14] More recently, Katherine Duncan-Jones has discovered much about Sidney's pictorial imagination by exploring whether his descriptions of works of art can be linked with actual visual objects.[15] But this method is of limited use, for various reasons. Even if the writers were directly imitating visual artefacts, the chances of our being able to make the tie-up are very small, for losses of paintings and sculptures have been large, while many inventories likewise must have disappeared, and those that survive are — like the poems themselves — far from precise on questions of artist, medium and subject-matter.

More importantly, it is intrinsically unlikely that the Elizabethan writers should be describing actual objects. What conceivable point was there in merely copying when, as Holofernes says to Nathaniel in *Love's Labour's Lost*, 'imitari is nothing'?[16] One of the most highly prized qualities of the artist in the period was his capacity for invention, for manifesting in his work of art his original concept or idea, or for transforming by originality of treatment the idea taken from another artist. The criterion applied both to poetry and painting: 'For by the name of poet we do not wish to say anything other than maker. And he is called a Poet not for his versifying, but principally for his subject-matter in as much as his materials come from him, and are made, and pretended, brought into being and suitable to Poetry.'[17]

[13]*Ancient Funerall Monuments* (London, 1631), p.430. Weever was also the author of *Faunus and Melliflora* (1600), one of the many imitations of *Hero and Leander*, and one that talks enthusiastically about art, especially pictorial art; see *Elizabethan Minor Epics*, edited by Donno, pp.253-80. [14]'The Sack of Troy in Shakespeare's *Lucrece* and in Some Fifteenth-Century Drawings and Tapestries', in *A Book of Homage to Shakespeare*, edited by I. Gollancz (Oxford, 1916), pp. 88-99. [15]'Sidney's Pictorial Imagination'. [16]IV.2.18-19. All quotations from Shakespeare's plays and poems are made from the edition of Peter Alexander (London and Glasgow, 1951). [17]G.B. Giraldi Cinthio, *Discorso . . . intorno al comporre de i romanzi* (Venice,

The essence of both poetry and picture lay in invention: 'la pittura é propria poesie, cioe inventione'.[18]

Thus the poet who followed an actual painting instead of inventing his own — in subject or treatment — was limiting himself to artistic second-class citizenship. The writer received no benefit from handing the painter the laurels, silently acknowledging the other's superiority by restricting his invention to the exact model offered by the painter, when the poet's wish was to establish his own art as the peer of the sister-art, if not its superior. This was especially true for the English poet of the 1570s and 1580s, whose art was not highly regarded, and whose moralistic critics (for example, Stephen Gosson, whose *Schoole of Abuse* (1579) may have prompted Sidney to write his *Apology for Poetry*) vigorously renewed the old charge that poets were liars and hence opposed the English poet's claim to be allowed to create fictions.[19] In fact, the story of his relationship with the painter will turn out to be linked closely with his desire to advance the art of poetry; and painting will turn out to play an important part in establishing the English poet's confidence in the ability of his language and art to vie with those of antiquity, a confidence expressed by the way Nashe in 1598 can in one breath speak of 'divine *Musaeus*. . . and a diviner Muse than him, *Kit Marlow*'.[20]

In this essay the method I have chosen for elucidating the relation of the two arts in the English Renaissance is first of all to review English terms, such as they are, for dealing with the visual arts. My aim is to establish what the common assumptions (albeit largely unconscious ones) about painting were in the last few decades of the sixteenth century. Against this background, and what is its complement, the state and status of painting at the time, I shall chart the growth of a slightly more sophisticated response towards the end of the century in an attempt to correlate what seems to be men's actual experience of seeing pictures with the formulae available to them for talking about painting, principally those derived from the classics. I shall argue that there comes a point when real visual experience affects what the writer comments on in the pictures he describes; thereafter I shall explore what the writer's debt amounts to in terms of his literary achievements.

1554), p.56 (my translation). Sidney and Puttenham firmly advance the poet as a maker, a creator. [18]Paolo Pino, *Dialogo di Pittura* (Venice, 1548), fol. 16ʳ. [19]For a review of the debate, see G. Gregory Smith, *Elizabethan Critical Essays*, 2 vols (Oxford, 1904), I, Introduction, pp. 61-86 and notes, and pp.341-44; also Russell Fraser, *The War Against Poetry* (Princeton, 1970). [20]*Nashes Lenten Stuffe*, in *The Works of Thomas Nashe*, edited by R.B. McKerrow, 5 vols (Oxford, 1958), III, 195.

Chapter II

TODAY a traditional view of painting, by no means confined to specialists, is as an art involving such elements as mass, colour, line, composition and draughtsmanship. Even a rudimentary teaching of the subject is likely to highlight some or all of these elements. Thus conditioned, we tend to think of such elements as intrinsic to painting as an art. But we are merely dealing in conventions, indeed in that particular convention of art formulated by the Renaissance itself. We nonetheless project our kind of awareness back on to the English sixteenth century. Alternatively, even if we realise that our traditional definition of painting only began to take root in England at the very end of the century, we tend to assume, because of the widespread destruction of the visual arts wrought by the Reformation and iconoclasm, that by the 1570s a kind of vacuum existed where the visual arts were concerned; as if all an English art-lover had to do was to embrace what were to him the new arts of the Renaissance and Mannerism. But neither conceptually nor linguistically was he equipped to do so, and a host of preconceptions stood in his way.

To take the question of language on a simple level, 'picture' in the late sixteenth century in England was an extraordinarily wide and vague word; it covered not only painting as we understand it, and the art of sculpture, as Alberti had used the term,[1] but also tapestry, heraldry, embroidery, marquetry, imprese and emblems. One early-seventeenth-century librarian had a category of 'Libri de Architectura. Pictura &c', but the only volume representing 'Pictura' is Horapollo's *Hieroglyphics*.[2] An individual impresa could be a 'picture'; so could a piece of sculpture, as in the description of Pygmalion's statue as his 'could Stone his picture'.[3] It could mean, in short, anything to do with a visual image, though not necessarily a visible image; a poet's description could be a picture too.[4] As expounded by John Dee, 'picture' has an almost metaphysical existence: 'To what Artificer, is not Picture, a great pleasure and Commoditie? Which of them all, will refuse the Direction and ayde of Picture?'[5]

'Painting', meanwhile, might be used without discrimination to mean

[1]See introduction to *Leon Battista Alberti: On Painting and On Sculpture*, edited by C. Grayson (London, 1972), p.10. [2]Northamptonshire Record Office, Finch-Hatton MS 4025, fol. 3[r]. [3]A. Saker, *Narbonus* (London, 1580), sig. Aii[r]. [4]For example, A. Fraunce, *The Third Part of the Countess of Pembrokes Yvychurch* (London, 1592), edited by G. Snare (Berkeley, 1975), pp.9,13,14,20 and so on. [5]Preface to Billingsley's translation of Euclid's *Elements* (London, 1570), sig. dii[v].

face-painting,[6] heraldry-painting, house-painting, or art-painting (or, for that matter, word-painting). This blurring could suit the writer, as when Edward Guilpin fulminates against cosmetics:

> . . . Then how is man turnd all *Pygmalion,*
> That knowing these pictures, yet we doate upon
> The painted statue . . .
> . . . These wenches know
> We are but fooles to be deluded so:
> Who for deluding us, to plague their sinne,
> Are turned to counterfaits, which their uncasd skin
> Quickly discovers, and to shadowes too,
> For making lovers shadowes as they doo.[7]

The imprecision also meant that the functions of, for example, the art-painter and house-painter might be mixed. Thus, the Sergeant-Painter was responsible for overseeing the painting of the Royal Palaces; while to us George Gower is a painter because of his portraits, to some of his contemporaries and certainly to his main paymaster, the Office of Works, he was a painter insofar as he was responsible for the painting of buildings.[8] It comes about, therefore, that the verb 'to paint' can be, to us, misleadingly used. In a letter probably of the 1570s to George Talbot, Earl of Shrewsbury, Robert Dudley, Earl of Leicester, recommends one Humphrey Bales for a pursuivant's place: 'He doth draw and paint excellently well, as may appear by a thing done for your Lordship by him.'[9] The modern reader tends to assume that Bales was an artist, but probably Leicester merely meant that Bales could devise and execute heraldic devices competently.

To indicate the art associated with Dürer, or Michelangelo, or Hilliard, writers resort to phrases like 'curious painting' or 'artificial painting',[10] as when Haydocke translates 'trattato dell'arte de la pittura' as the 'arte of curious paintinge'. The art-painter is a 'curious painter',[11] and Stephen Bateman, who was sufficiently keen on

[6]Haydocke's translation of Lomazzo includes a diatribe against cosmetics. Sir George Buc openly disparages art-painting because (among other reasons) of its kinship with face-painting; see Stowe's *Annales*, 3rd edition (London, 1615), p.986. Lyly speaks of 'viewing the Ladyes in a Painters shop'; as the setting is Italy, it is not at first apparent that the painter is a cosmetician; see *The Complete Works of John Lyly*, edited by R.W. Bond, 3 vols (Oxford, 1902), II, 11. [7]*Skialetheia, or, A shadowe of Truth* (London, 1598), sigs C5ᵛ-C6ʳ. [8]See E. Mercer, 'The Decoration of the Royal Palaces from 1553-1625', *Archaeological Journal*, 110 (1953), 150-63. Also his *English Art 1553-1625* (Oxford, 1962), pp.152-53. Even as late as 1664 we find Sir Roger Pratt specifying that Robert Streeter, Sergeant-Painter, should execute decorative schemes associated with the cornice of Clarendon House; see R.T. Gunther, *The Architecture of Sir Roger Pratt* (Oxford, 1928), p.147. [9]Quoted by Sir Anthony Wagner, *Heralds of England: a History of the Office and College of Arms* (London, 1967), p.200. [10]Edmund Bolton, *The Elements of Armories* (London, 1610), p.84. [11]A phrase used, for example, by Angel Daye, *The English Secretorie* (London, 1586), p.44.

painting to write instructions on limning, says of the Italian painter that his nature 'is to be curius'.[12] This adjective by no means aided the cause of art-painting in England at a time when 'curious' tended to have pejorative overtones ('. . .*piked diligence. . . A little curious and affectated*').[13] Often the English say that an art-painter 'shades' or 'shadows', as when Lyly speaks of 'every painter that shadoweth a man'.[14] Even in the middle of the seventeenth century the term is still in use; Milton has Adam awake to find

> Before mine Eyes all real, as the dream
> Had lively shadow'd

where the word-play suggests 'painted' without intrusive anachronisms disturbing Adam's vocabulary.[15] I shall return to the significance of this old-fashioned but important term.

When Peacham defines painting on the first page of *The Arte of Drawing with the Pen* (1606), he calls it an art which 'either by draughte of bare lines, lively colours, cutting or embossing, expresseth anything the like by the same'. By 1606 there were numerous definitions of painting in European handbooks which one might have expected Peacham to use, since he was writing a practical handbook himself; Lomazzo's definition, for example, had been translated by Haydocke.[16] But it is clear from Peacham's garbled definition, which owes as much to Vitruvius as to sixteenth-century authors, that he either did not in fact know them or had understood them imperfectly.

Usage here indicates a lack of contact with European models, or at best an insufficient contact for a full understanding of the concepts involved, as well as a deficiency in English words, since Peacham seems to mean something like 'arts of *disegno*'. 'Design' in this sense, which becomes so extraordinarily popular by the mid-seventeenth century in England, is only just beginning to occur by 1606;[17] and Ben Jonson, one of its pioneer users, in both *Discoveries* and *An*

[12]In his additions to Trevisa's translation of Bartholomaeus Anglicus, *De proprietatibus rerum; Batman uppon Bartholome* (London, 1582), p.394. By contrast, he calls the 'Frenchman subtill, & therefore manye times, although theyr works be far worse then the Englishmans is, they obteine rewarde when the other goeth without. The Dutchman [German?] for imagination & oile hath proved singular, his shift is to be tedious and long, fayning his work, that thereby it may seme both chargable and laborius. The English man oftentimes marreth all or maketh nothing.' [13]J. Baret, *An alvearie or triple dictionarie, in Englishe, Latin and French* (London, 1573), sig. R1[r]. [14]Preface to *Euphues*, 1st edition (London, [1578]), sig. Aii[v]. Lyly's references to painting are rather interesting, not least in that while for the most part they are literary and theoretical, they show some awareness of techniques, such as the reference to silverpoint (*Works*, II,167). [15]*Paradise Lost*, VIII.310-11. [16]*Tracte, 1,13.* [17]The only discussion known to me that does justice to the importance of 'design' in the seventeenth century is Bernard Schilling's *Dryden and the Conservative Myth* (New Haven, 1961), pp.24 ff.

Expostulacion with Inigo Jones, manages to tinge it with the sense of 'underhand purpose'. In the first work, writing of the nobility whom a prince cannot trust, he says that such 'remove themselves upon craft, and designe (as the *Architects* say) with a premeditated thought to their owne, rather then their *Princes* profit'. And deploring Inigo Jones's handling of masque, in the second passage he writes:

> This is y^e money-gett, Mechanick Age!
> To plant y^e Musick where noe eare can reach!
> Attyre y^e Persons as noe thought can teach
> Sense, what they are! which by a specious fyne
> Terme of y^e Architects is called Designe![18]

Such verbal manœuvres would scarcely have been possible if the full artistic sense of 'design' had been widespread.

Although the concept of design is embodied in works of literature before 1600, the concept itself is described in other ways, such as '*Idea,* or fore-conceit';[19] and when Sir John Harington wishes to praise Leonardo da Vinci for something like 'design', what he actually says is that Leonardo is 'so excellent in the Idea, or the conceived forme of his worke, that though he could finish but few workes, yet those he did, had great admiration'.[20]

Where Lomazzo writes about 'arte disegnatrice', Haydocke is floored. Lomazzo speaks of the four parts of painting which 'si servono all'arte disegnatrice, cioe alla pittura lineare, scultura, architettura, ed all celatura, cioe al mosso rilievo'. Haydocke reduces the four parts to two — 'shortnings, intersections &c.' — and says that they 'serve to the arte of Drawing, Carving, Architecture, and Imbossing halfe rounde called *mezzo rilievo*'.[21] It seems that Haydocke did not fully understand what Lomazzo was talking about.

This is not surprising as one discovers that the other facet of 'design', that linked with *disegnare* meaning to draw (understood, skilfully) is lacking until surprisingly late in the seventeenth century in England.[22] 'To draw' for the Elizabethan means, typically, to put down the first rude draught; the herald Gwillim's phrase, 'the delineated rough draught or shaddow of a new-found method', shows how it has the

[18]*Works*, edited by C.H. Herford, Percy and Evelyn Simpson, 11 vols (Oxford, 1947-52), VIII, 404 and 598. [19]Sidney, *Apology for Poetry*, edited by G. Shepherd (London, 1965), p.101. On the theory of *disegno*, see E. Panofsky, *Idea* (Leipzig, 1924), translated by J.J.S. Peake (Columbia, S.C., 1959, reprinted New York, 1968). [20]*Orlando Furioso* (London, 1591), notes to Book XXXIII, p.277. Hoby translates Castiglione's 'il bon disegno' as 'a good pattern'; *Il Libro del Cortegiano*, I.49; edited by V. Cian (Florence, 1946), p.123; *The Book of the Courtier*, the Everyman edition (London, 1928), p.78. [21]Lomazzo, *Trattato*, 3 vols (Rome, 1844), II,22; Haydocke, *Tracte*, 5,189. [22]On drawing (and its relation to *disegno*), see C. de Tolnay, *History and Technique of Old Master Drawings* (New York, 1943); M. Poirier, catalogue to 'The Age of Vasari' exhibition (Notre Dame and Binghampton, 1970).

connotation of imperfection and crudity, not artistry. Exceptions to this are very rare in the sixteenth century; possibly Harington's reference to the 'excellent drawers of time past' is one, though as 'draw' is often loosely used to mean 'paint' (as in the 'curious paynter . . . drawyng a perfect peece of *Lantskip*'), one cannot be sure.[23] Thomas Twyne, translating Petrarch, says that both pictures and statues sprang 'from one Fountayne, to wit, the art of drawing',[24] but we do not know that Twyne himself associates skill with drawing. Far more common are usages when clearly the word does not imply skill. Occasionally 'draw' suggests drawing from the life, as when Ophelia says that Hamlet 'falls to such perusal of my face / As 'a would draw it'.[25] More often it is associated with a conceptual image; thus an Elizabethan instructs a painter: 'behynde must be a panther and a crocodyll standynge ryghte up, trewly drawn in theyre coloures as gesner descreibeth them'.[26] Granted that Hilliard's treatise of the 1590s, 'The Arte of Limning', has much to say about drawing from the life, the very extent of the efforts he has to make to convey his exact meaning shows that he did not expect his audience, of painters, limners and lovers of both arts, to take his point readily. Henry Peacham's *Arte of Drawing* (1606) marks a revolution in England since he is discussing at length, in print, the techniques of drawing and, moreover, before discussing colour.[27]

But until the seventeenth century, so demeaning were the associations of the word 'drawing' that John Dee, describing an art of draughtsmanship in his preface to Billingsley's Euclid (1570), invents a new word for it, 'Zography'. The neologism is avant-garde for England since it means 'drawing from life'; Dee, though, praises 'Zography' not as an art, but as a science, closely interrelated with geometry, arithmetic, perspective, 'Anthropographie, with many other particular Artes'.[28] Such an alignment, with a strong tradition behind it, shows how drawing is worthy of esteem only insofar as it represents Aristotle's *graphice*, that is primarily a technical skill, which the English thought of as possessed by the geometrician, the geographer and the herald.[29]

[23]*Orlando Furioso*, p.277; Daye, *The English Secretorie*, p.44. [24]Translation of *De remediis utriusque fortunae* as *Phisicke against fortune* (London, 1579), quoted by Baxandall, p.56. The precept is found in Vitruvius, I.6. [25]II.1.90-91. [26]BL, Sloane MS 1096, fol.1v (datable to early 1580s). [27]See pp.10-45, for Peacham's method 'to teach draught'. Peacham retitles his 1612 version *Graphice*, as though the term used by Aristotle might dispel his readers' prejudice against the practice of drawing. For a discussion of the place of drawing in Peacham's day, see F.J. Levy, 'Henry Peacham and the Art of Drawing', *JWCI*, 37 (1974), 174-90. [28]Sig. diiv. [29]*Politics*, VIII,3. This issue is discussed by A.Moffat, 'Lomazzo's Treatises in England in the Late Sixteenth and Early Seventeenth Centuries' (unpublished M. Phil. thesis, University of London, 1975), pp.39ff., where he shows the importance of commentaries on Aristotle, such as that by Lefèvre d'Étaples, *Politicorum libri octo* (Paris, 1506), fols 118r-19r.

As it happens, 'drawing' in this sense was quite a lively tradition in England, fortified by drawing as practised in calligraphy. Many men were amateur artists. For example, Dee drew the title-page for one of his books,[30] and Burghley drew for the purposes of heraldry and recording buildings. Drawing (of some kind) appeared daily on the timetable established for the young Earl of Oxford, whose education Burghley supervised.[31] And some at least of the educational treatises, such as Mulcaster's *Positions* (London, 1582), had recommended the inclusion of drawing on the curriculum.[32] Drawing escaped the censure attached to painting for a variety of reasons: it did not involve messy colours, it was the tool of arts and sciences. It was gentlemanly to have a proficiency in the arts of fortification and surveying, and to be able to sketch in order to practise heraldry, 'armories' (hence the general use of the term 'trick', to mean a quick rough drawing — a term borrowed from the vocabulary of heralds). So why did such drawing not prepare the way for an acceptance of drawing as an art, *disegno*, and thereby encourage an appreciation of the visual arts? Two factors prevented this.

Firstly, as a technique it was conservative to a degree, involving copying either an existing image, or the idea in the head (Dee's sketch referred to above shows no signs of 'Zography'). It might depend on tracing; in 1634 John Bate, the author of a manual on, among other things, drawing and painting, understood the artistic importance of learning to draw from the life, yet devoted more space to his wider audience, the amateurs who wanted instruction in copying and tracing.[33] In other words, it did not connote sketching from the life. As for the calligraphers' drawing, though at times extremely decorative, it bears the marks of tracing, as with the continuous strong outline of figures in John Scottowe's famous figure capitals, or the decorated alphabet at the Victoria and Albert Museum.[34] Thus such 'drawing' was opposed to the technique of the sixteenth-century Continental painter. John Shute's *The first and chief groundes of architecture* (1563), published after he had been to Italy under the patronage of the Earl of Northumberland, is to the modern reader a puzzling work,

[30]The drawing for his *General and rare memorials pertayning to the Perfect Arte of navigation* (London, 1577) is in the Bodleian Library, MS Ashmole 1789. Another example of the amateur artist is Abraham Fraunce, who did an illustration for the cover of his 'Emblemata', Bodleian Library, MS Rawlinson D.345. [31]B.M. Ward, *The Seventeenth Earl of Oxford* (London, 1928), p.20. [32]pp.34-36. [33]*The Mysteries of Nature, and Art* (London, 1634), pp.104 ff. (a treatise which has the distinction of being included in Lord Herbert of Cherbury's bequest of books to Jesus College, Oxford in 1648). The ambitious triumphal arch attributed to Robert Pytt, in the Victoria and Albert Museum, *c*.1545, shows signs of tracing (illustrated by John Summerson, *Architecture in Britain 1530 to 1830*, 5th edition, revised (Harmondsworth, 1969), Plate 24). [34]See *John Scottowe's Alphabet Books*, edited by Janet Backhouse, Roxburghe Club (London, 1974), pp.12-13.

since for all Shute's reference to what he has seen and drawn in Italy, his book is based entirely on what can be seen in architectural treatises; one of the main reasons for the absence of any first-hand experience in his text or illustrations must be his lack of a technique in drawing from the life, in sharp contradistinction to Inigo Jones's acquisition of such a technique a few decades later.

Secondly, the English tradition of drawing was not considered an 'art', but a functional technique appropriate to certain professional competences — precisely why it escaped reproof when the practice of art-painting was often censured; but by the same token, it could never become art. There is virtually no continuity between sixteenth-century English drawing and the art of drawing that Inigo Jones learnt and practised.

An Englishman's idea of the place of drawing in the painter's art is probably fairly indicated by Edmund Bolton (1575?-1633?). Bolton, a Roman Catholic, was interested in painting, offering, for example, the first English dictionary definition of landscape-painting.[35] He travelled in Italy, and while there gave a book to Inigo Jones (in 1606) hailing him as the man through whom 'there is hope that sculpture, modelling, architecture, painting, acting and all that is praiseworthy in the elegant arts of the ancients, may one day find their way across the Alps into England'.[36] He was also a friend of Michael Drayton, and altogether certainly not unsophisticated.[37] Yet in 1609 we find him writing: 'And all Painters wee see doo first make a rude draught with chalke, coale, lead or the like, before they limn a Picture, or lay a Colour.'[38] When Englishmen wish to indicate the drawing that is made before paint is applied, they often say 'trick', 'purfle', or like Bolton refer to a 'rude draught'. Alberti, writing in the 1430s, says that 'It is not unusual . . . to see only a good circumscription — that is, a good drawing — which is most pleasant in itself.'[39] The English, one

[35]In *The Elements of Armories*, glossary at sig. Dd4ᵛ; borrowed with acknowledgement to Bolton by T. Blount, *Glossographia* (London, 1656), sig. Y8ᵛ. [36]The book was a copy of J.F. Bordinus, *De rebus praeclare gestis a Sixto V Pon.Max.* (Rome, 1588), now in the library of Worcester College, Oxford. The inscription is transcribed by J.A. Gotch, *Inigo Jones* (London, 1928), p.43. [37]Bolton was probably the 'E.B.' who contributed verses to the Countess of Bedford which were set before Drayton's *Mortimeriados*, and later he proposed Drayton as one of the founder-members of the royal academy which he wished James I to establish. Perhaps his friendship with Drayton lies behind the enthusiastic descriptions of landscape-paintings in *Mortimeriados*. For further details of this curious character, see *DNB*. [38]*Elements of Armories*, p.84. A preliminary rough sketch in, for example, charcoal, was of course standard practice for the European painter. The Elizabethans (and most early Jacobeans), though, show no awareness of any other sort of drawing. [39]*Della pittura*, translated by John R. Spencer as *On Painting*, revised edition (New Haven and London, 1966), p.68. The Latin version says: 'At sola circumscriptio plerunque gratissima est'; *Alberti*, edited by Grayson, pp.66-67. As late as the 1620s, the well-informed Edward Norgate says that when all is said and done, a drawing 'is but a drawing, which conduces to make profitable things,

hundred and fifty years later, have by contrast no concept of a drawing as a work of art in its own right, only as a flat outline preliminary to a colouring process (this fact is not unconnected with the small number of Tudor and early Stuart drawings known to exist).[40]

The point is usefully clinched by Inigo Jones's pupil and follower, John Webb, in his *Vindication of Stone-Heng Restored* (1655), when defending Jones's interpretation of Stonehenge against the criticisms of Dr Charleton and William Camden. He says that Camden was a great scholar and so forth, 'but of his Knowledge in Arts Mathematical, or Design, he hath given us no great Testimony'; while Jones, on the other hand, was 'eminent for *Architecture,* a great *Geometrician,* and in designing with his Pen (as Sir *Anthony Vandike* used to say) not to be equalled by whatever great Masters in his Time, for *Boldness, Softness, Sweetness,* and *Sureness of his Touches'.* And later:

> Now, though how well skilled soever [Dr Charleton] would have Mr. *Camden* to be in the Art of designing, I will not debate; I sincerely wish nevertheless, that not only he had seen, but also that all the Gentry of *England* were as well knowing in this Art, as ever Mr. *Jones* was; for, I must tell you, that what was truly meant by the Art of Design, was scarcely known in this Kingdom, until he, under the Protection of his late sacred Majesty, and that famous *Mœcenas* of Arts, the Right Honourable *Thomas* Earl of *Arundel* and *Surry,* brought it in Use and Esteem among us here.[41]

If Webb is right, then Haydocke's uncertainty over *l'arte disegnatrice* is easily understandable: the English visual arts were not founded on the Italian technique of drawing, of artfully careless *desinvoltura,* incorporating sketching from the life, nor on the concept of *disegno.*[42]

Only with the 1620s is connoisseurship of pictures assumed to start with an appreciation of drawing, when Sir Henry Wotton, in his *Elements of Architecture* (1624), says that in appraising a picture we are first 'to observe whether it bee well *drawne,* (or as more elegant *Artizans* tearme it) well *Design'd'.*[43] Such an attitude can thereafter be found in print, affecting even the platitudes of poetry-painting com-

but is none it selfe', even though he praises 'the profound and exquesite study of Designe'; *Miniatura,* edited by M. Hardie (Oxford, 1919), pp.79 and 83-84. [40]See John Woodward, *Tudor and Stuart Drawings,* edited by K.T. Parker (London, 1951). [41]*A Vindication,* pp.11,19. [42]Compare Summerson's remarks on Jones's draughtsmanship in *Architecture in Britain,* p.112: Jones's English contemporaries 'might be exquisite calligraphers and capable of producing the neatest possible "plats" and "uprights", but they had no conception of the free, suggestive draughtsmanship which had now for a hundred years been the instantaneous medium of expression for Italian painters, sculptors, and architects. . . when we meet with Inigo Jones's earliest surviving sketches in 1605 we know that we have finally crossed the threshold from the medieval to the modern'. Much of the present study could be said to be exploring the implications of this remark. [43]Facsimile introduced and annotated by F. Hard (Charlottesville, 1968), p.86 (misnumbered 76).

parisons. For example, the biography of Arthur Lake, Bishop of Wells, prefixed to his *Sermons* (London, 1629), draws a comparison between the art of a sermon and the art of a picture, 'in the framing whereof the chiefe thing that requires the Artisans skill, is to draw his lines in their just number and proportion, so as may expresse all the parts of the thing described'. Not many years earlier, the writer would have found a way of praising Lake's art for its simplicity; now well-proportioned drawing becomes the sign of true art. Or to take a literary example, a character in Philip Massinger's *The Picture* (1630) praises a portrait because it shows the sitter

> With more then humane skill limde to the life;
> Each line, and linament of it in the drawing
> Soe punctually observed that had it motion
> In so much 'twere her selfe.[44]

The linguistic problem presented by the concept of excellent draughts-manship has still not been very smoothly solved. But at any rate Massinger puts across that concept, whereas at the beginning of the century it hardly exists, let alone a word by which to express it. One must surely question how far any society, or even its art-conscious minority, can appreciate an art of whose fundamental skill it is un-aware. How far do we observe qualities for which we have no word or phrase?

The terms discussed so far are perhaps the most telling ones, but there are many other examples of usages that suggest either con-servatism, or a lack of contact with up-to-date artistic models, or both. For example, 'image' can be found meaning 'statue' at least up to the late 1620s. 'Counterfeit' is often used instead of 'portrait' (even by Shakespeare), a good example of how art in England was liable to come under attack by the moralist, since 'counterfeit' inevitably carried associations of 'false' and 'deceptive'. 'Sculpture' is often expressed by 'graving'; engravers were called cutters, and engravings, cuts (book illustrations can be found described as 'curious cuts' into the eighteenth century). The phrase 'in relief' is not known; instead the word 'embossed' is used. Whereas the French 'pourfile' has developed the sense of 'profile' by early in the seventeenth century, 'purfle' still lingers in English as a herald's term, and if borrowed to describe depiction, means a rough outline. The paucity of terms to do with the architect and his profession is well known; R.D., probably Sir Robert Dallington, translating part of Colonna's *Hypnerotomachia* (1499), has to concoct English equivalents for many of Colonna's terms, often with amazing results. R.D., incidentally, does not seem to know the

[44]I.1.167-70; *The Plays and Poems of Philip Massinger*, edited by P. Edwards and C. Gibson, 5 vols (Oxford, 1976), III, 204.

term 'landscape', and instead speaks of 'parergie'.[45]

As we have already seen, the question of artistic terminology is much more than a purely verbal one. When a translator knows what his author is talking about, he can usually find a way of expressing it. His problems begin when he is not clear about the concepts involved. For example, the idea of the pleasing sketch is nominally to be found in English as early as 1561, since Castiglione describes it to illustrate *sprezzatura* in Book I of *Il Cortegiano*, that source of so much apparent familiarity with up-to-date painting among Englishmen. But to put Castiglione's original side by side with Sir Thomas Hoby's translation shows Hoby's problem. Castiglione writes:

> Spesso ancor nella pittura una linea sola non stentata, un sol colpo di pennello tirato facilmente, di modo che paia che la mano, senza esser guidata da studio o arte alcuna, vada per sé stessa al suo termine secondo la intenzion del pittore, scopre chiaramente la eccellenzia dell'artefice.[46]

This becomes:

> Oftentimes also in painting, one line not studied upon, one draught with the Pensell sleightly drawne, so it appeareth the hand without the guiding of any studie or art, tendeth to his marke, according to the Painters purpose, doth evidently discover the excellencie of the workeman.[47]

It seems to me extremely hard to discover the spirit of Castiglione's meaning in Hoby's version, especially as the Elizabethan reader might well take 'Pensell' to mean 'paint brush', and 'drawne' to mean 'painted'. By contrast, in 1601, Philemon Holland, translating a passage from Pliny on unfinished paintings, expresses something like the effect of a sketch; in certain such paintings, he says, 'imperfect tables, a man may (as it were) see what traicts and lineaments remaine to bee done, as also the very desseignes and cogitations of the artificers'.[48]

Nor was the concept of the sketch Hoby's only problem in 1561 in translating Castiglione's discussions of art. He has further difficulties in two key areas, perspective and chiaroscuro. Castiglione, the friend of Raphael, in discussing perspective, writes:

> Ed a questa bisogna un altro artificio maggiore in far quelle membra che scortano e diminuiscono a proporzion della vista con ragion di prospettiva.[49]

[45]*The strife of Love in a Dreame* (London, 1592), sig.H4r (fol.28r), introduction by Lucy Gent (New York, 1973),p.63. [46]*Il Cortegiano*, I.28 (p.69). [47]*The Book of the Courtier*, p.49. [48]Pliny, *Naturall Historie,* translated by Holland, 2 vols (London, 1601), II, 550; compare Pliny, 'quippe in iis lineamenta reliqua ipsaeque cogitationes artificium spectantur', *Natural History*, Loeb edition, 10 vols (London, 1938-63), IX, 366. [49]*Il Cortegiano*, I.51 (p.126). The Everyman edition of Hoby's translation suggests: 'And in

Hoby produces something impossible to visualise, partly because he lacks the term 'foreshorten' by which to throw light on 'perspective':

> And in this point he must have an other craft that is greater to frame those members, that they may seeme short, and diminish according to the proportion of the sight by the way of prospective.

And what did the Elizabethan reader make of the following?

> . . .as the good painters with a shadow make the lights of high places to appeare, and so with light make low the shadowes of plaines.[50]

Even as late as 1598, Haydocke converts Lomazzo's 'la chiarezza, e la oscurezza dei colori' to '*Heighthninges* and *Deepeninges, Lightninges and shaddowes*', scarcely a very true rendering of the Italian.[51].

The desperate shortage in sixteenth-century English of terms to do with art is a clear index of a lack of contact with works of art being produced, or recently produced, in Italy and France. This rather obvious point is worth making because it is periodically claimed that certain major English writers, apart from Sidney, and beginning with Shakespeare, were thoroughly *au fait* with Continental art, in thought, word and visual experience, as though such men, while they lacked Sidney's financial and cultural advantages, could rise above the level of visual culture and assumptions that existed in, say, London.[52] The truth is surely that however quick the writers were to pick up hints and to grasp the implications of what they saw or heard about, their starting point was English visual culture of the period. The changes they noticed in the visual arts over, particularly, the 1590s — whether those changes were inaugurated then, or were simply registered then having occurred before — were basically the changes that their contemporaries might have noticed, however much more profoundly and subtly the writers observed them.

The state of affairs I have suggested could be challenged on the grounds that we have lost (as well as the works of art themselves) the conversations, the commissions to agents, the letters, where the artistic terms were most likely to be used.[53] But this argument is not

this another and greater skill is needed to represent those members that are foreshortened and grow smaller in proportion to the distance by reason of perspective' (p.80). [50]*The Book of the Courtier*, p.94. The Italian reads: 'come i boni pitorri, i quali con l'ombra fanno apparere e mostrano i lumi de' rileve; e così con lume profondano l'ombre dei piani'; II.7 (p.148) (compare 'like the good painters, who use shadow to bring out the highlights on raised surfaces; and thus with light deepen the shadow of plane surfaces'). [51]*Trattato* (1844), I,324; Haydocke, *Tracte*, 3, 97. [52]I am thinking of the assumptions of works such as H.C. Fairchild's *Shakespeare and the Arts of Design* (Columbia, Mo., 1937), and Terence Spencer's 'The Statue of Hermione', *Essays and Studies*, 30 (1977), 39-49. [53]An interesting example of such correspondence is re-

wholly convincing. If such terms were in circulation though not in print, why does Richard Haydocke in 1598, well placed in Oxford for contacts with other art-lovers and Italian speakers, have so much difficulty in rendering such words as *figure* (which he loosely translates as 'pictures')[54] or *l'arte disegnatrice* (which, as we have seen, he virtually ignores)? And Sir Henry Wotton, introducing his *Elements of Architecture* in 1624, says that he must complain, like the German translator of Vitruvius, of 'some defect of *Artificiall* tearmes' in the English language. English and German, he says, 'for the most part in tearmes of *Art* and *Erudition,* [retain] their originall povertie, and rather [grow] rich and abundant, in complementall phrases and such froth'.[55]

If, then, up-to-date concepts and terms were signally lacking we may ask what took their place. The concept of painting which, for various reasons, prevailed in England until the 1570s and for many men lingered long after was, I would argue, the medieval one of line and colour. Lack of contact with the Continent was one cause of this conservatism. Another was — ironically, in a way, since it represented England's one pictorial art which could rival those of Europe — the art of limning which, derived from medieval illumination, was enjoying a strong revival, among amateurs as well as professionals, after a period of decay. The revived skill could be used for the illustration of initials in charters and such like,[56] and in armories, that Elizabethan passion shared even by the Archbishop of Canterbury, Matthew Parker, who went so far as to have 'our church's arms in colours' set out in *De Antiquitates Britannicæ Ecclesiæ,* and to keep within this house 'in wages, drawers and cutters, painters, limners, writers, and book-binders'.[57] The ubiquitous popularity of heraldry, which Elizabethans casually thought of as a species of 'painting', and which led to the use of heraldic schemes for the decoration of halls and palaces — for example, at Theobalds and Chichester Bishops' Palace — confirmed painting as an art of colour.

'Lively colours' are what many men immediately thought of when the subject of praiseworthy painting came up; and 'lively colours' — not perspective, not shadow — were, in their eyes, what allowed the skilful painter to achieve lifelikeness. Thus as late as the 1620s, Robert Burton describes the illustrations to bestiaries and similar books as showing their subjects 'truely expressed in lively colours', and to

produced and discussed by I. Whalley, 'Italian Art and English Taste: an Early-Seventeenth-Century Letter', *Apollo,* 94 (1971), 184-91. [54]*Trattato* (1844), I, 406; Haydocke, *Tracte,* 4, 167. [55]*Elements,* Preface, sig. ¶ 4ᵛ-A1ʳ. [56]See Erna Auerbach, *Tudor Artists* (London, 1954). [57]*Correspondence,* edited by John Bruce and Thomas Thomason Perowne, Parker Society (Cambridge, 1853), pp.425-26. His picture inventory of 1577 is printed in *Archaeologia,* 30 (1844), 1-30 (pp.10-12); he collected predominantly portraits.

Henry Hawkins, in 1633, integrity of mind is 'the livelie coulour of God'.[58] The emphasis still survives in the expression 'to paint someone in his true colours'.

Until the 1580s, and for many until long after, colour was the chief criterion of painting, and it is interesting to see that colour was the one area where Haydocke, so aware of the artistic sophistication of the Italians, felt qualified as the result of his experience as a painter to add to Lomazzo's *Trattato*.[59] Even sculpture tended to be an art of colour, as a result of the habit of painting statues, even *'Regall Statues'*, which, said Sir Henry Wotton, 'I must take leave to call an English Barbarisme'.[60] And Shakespeare plainly does not expect his audience to be shocked at the idea of Giulio Romano's statue of Hermione: 'The statue is but newly fix't, the colour's/Not dry.'[61]

An unfortunate consequence of the conception of painting as an art essentially of colour was that art-painting became infected with the obloquy attached to other forms of 'painting' — cosmetics (bad for the morals and for the health), or the 'false colours' of rhetoric.[62] Even worse, it lay dangerously close to the trade of mere house painters, the daubers, 'the ridiculous fraternitie of silly Wall-washers', as Abraham Fraunce once scornfully wrote.[63]

The medieval technique (represented, for example, by Theophilus' *De diversis artibus*, probably written in the first half of the twelfth century)[64] assumed that the painter proceeds from an outline of a figure, to the underpainting, or *adumbratio*, and thence to the skilled laying on of colours.[65] Drawing, as a necessary and intrinsic art of the painter, is not singled out. Some three hundred years later the instructions of Cennini (born *c*.1370) to the painter, medieval though they are in contrast to Alberti's treatise on painting written in the 1430s, include precepts on practising drawing from the life, and the use of such expertise before proceeding to the art involved in applying colour.[66] In England in the second half of the sixteenth century as-

[58]*Anatomy of Melancholy* (Oxford, 1621), p.352; *Partheneia Sacra* (London, 1633), sig. Aiiii[v]. [59]*Tracte*, III, 125-26, 'A briefe censure of the booke of colours'. [60]Wotton, *Elements*, p.90. [61]*The Winter's Tale*, V.3.48-49. Another example of the Elizabethan fondness for colour is the extensive painting of walls of buildings (Mercer, 'The Decoration of the Royal Palaces from 1553-1625'). [62]Colour, as a metaphor, is discussed by W. Trimpi, 'The Meaning of Horace's *Ut pictura poesis*', *JWCI*, 36 (1973), 1-34. The false colours of rhetoric are repeatedly criticised by many of the writers cited by R.F. Jones, 'The Moral Sense of Simplicity', *Studies in Honor of Frederick Shipley* (St Louis, 1942), pp.265-87. [63]*The Third Part of the Countess of Pembrokes Yvychurch*, edited by Snare, p.8. [64]Translated and edited by C.R. Dodwell (London, 1961). [65]E. De Bruyne, *Études d'esthétique médiévale*, 3 vols (Bruges, 1946), I, 301. See also Gerhard B. Ladner, 'The Concept of the Image in the Greek Fathers and the Byzantine Iconoclastic Controversy', *Dumbarton Oaks Papers*, 7 (1953), 18-19. [66]*Il libro dell'arte*, translated by D.V. Thompson, Jr. (New Haven, 1933), especially ch.28 (p.15).

sumptions about the painter's practice, as we can glean them from the dictionaries and other usages, follow the earlier pattern. The painter's first step is the delineation of the image, a delineation which is assumed to be lacking in skill (a 'rude draught'); this is followed by under-painting, then by the application of colours, which, if well done, shows that the painter is an artist, not a crude workman. Thus Lyly describes 'the *Elizabeth* of *Euphues*' as 'but shadowed for others to vernish, but begun for others to ende, but drawn with a black coale, for others to blaze with a bright coulour'.[67] Even John Florio succumbs to the old-fashioned conventions about painting accepted in his adopted country, defining *ombra* as (among other meanings) 'the first draught in painting or drawing before it be finished'.[68] As late as the 1620s George Hakewill, whose quite extensive remarks on the art of painting show that he was no enemy to it, talks about the painter's procedure in terms which could come from the 1430s, or even the 1330s: 'Wee see the *Limmer* to begin with a rude draught, and the *Painter* to lay his grounds with shaddowes and darksome colours.'[69] 'Shaddowes', I would suggest, are, like Florio's *ombra*, an echo of *adumbratio*.

This generalisation about procedure is sweeping, and is of course based on verbal usages, not documentation on actual paint-ers. Obviously there were skilled up-to-date painters (many of them foreigners) working in England. But I am trying to elicit the basic ideas about painting in men's minds, because it was on the basis of common assumptions and expectations that spectators noticed changes in the art. Elyot's translation of *adumbro* in *Bibliotheca Eliotae* (1545) indicated a range of expectations. First, 'to make or gyve shadowe, to represent or expresse, as peynters doo, that do shadowe ymages in playn tables [that is, flat paintings as opposed to sculpture], to make them show imboced or round.' This was reasonably in keeping with European practice, but he then picked up another, older meaning: 'Some do suppose that it signifieth, to trycke a thynge, or draw it grossely, as paynters doo at the begynning.' Finally he associated it with fiction: 'It signifieth also to feyn or dissemble a thing.'

It is telling that Cooper in his *Thesaurus* (1565) followed Elyot to the extent of keeping all parts of the definition including what might look like the archaic portion, as though nothing had changed since 1545. The basically medieval procedure whereby the painter set down the 'shadow' of a figure (*adumbratio*), and then proceeded to colour it, did not disappear, even though by the 1580s a minority had begun to see painting as an art which produces the illusion of three dimensions on a plane surface by means of shading and perspective.[70]

[67]*Works*, II, 205. [68]In *Queen Anna's New World of Words* (London, 1611). [69]*An Apologie or Declaration of the Power and Providence of God* (Oxford, 1627), p.47. His discussion of the visual arts is at Book III, Sect.3, 247-49. [70]Several versions of this fifteenth-century definition of painting can be found, starting in the 1580s: Puttenham,

Apart from the expected conservatism of the theorists, the old conception of painting was kept alive by the heralds, both professional and amateur. How they did so can be shown by a passage in Gwillim's heraldry treatise, of 1611, on blazoning. Gwillim says it shall be called 'umbrated' when the representation of the charge consists only of 'the simple shadow thereof, which in Latin is called *umbra*'. He goes on: 'And the Portraicting out of any thing umbrated, is nothing else but a sleight and single draught or Purfle, traced out with a Pensill, expressing to the view a vacant forme of a thing deprived of all substance, which must be done with some unperfect or obscure colour, as Blacke, or Tawny, unlesse the Field bee of the same Colour.'[71] In other words, he is describing the outline and underpainting that precedes the painter's demonstration of his mastery of colours.

Such an anachronism would be of no interest in a discussion of painting, were it not for the fact that in England at the time heraldry impinged on painting.[72] It tended to be regarded by many men as an art of picture, also an art of painting. Even Edmund Bolton, interested in 'artificiall painting', clearly sees heraldic painting as basically similar to it, and armorial arms 'quickned with the light of colours'.[73] Socially it was desirable whereas painting was not; gentlemen and would-be gentlemen in England prided themselves on their skill in heraldry, which, it was argued, was virtually one of the liberal arts, and hence entitled to considerable respect.[74] In England it had its own well-developed technical vocabulary, in sharp contrast to art-painting.[75]

The Arte of English Poesie (1589), edited by G. Willcock and A. Walker (Cambridge, 1936), p.304; R.D., *The strife of Love in a Dreame*, fol.28ʳ, translating F. Colonna, *Hypnerotomachia Poliphili* (Venice, 1499); Hilliard, 'The Arte of Limning', *Walpole Society*, 1 (1911-12), 19-20, following Lomazzo (Haydocke, *Tracte*, 1, 13); Wotton, *Elements*, p.83. It is also echoed by Thomas Milles, *The Treasurie of auncient and modern times* (London, 1613), a translation from various authors, together with remarks of his own, p.365. Milles (d.1627?) is a writer who shows quite an interest in painting. [71]*A Display of Heraldrie* (London, 1611), p.42. The meaning of 'shadow' as a technical term in heraldry is discussed by H. Stanford London, 'The Ghost or Shadow as a Charge in Heraldry', *Archaeologia*, 93 (1949), 125-49 (I owe this reference to Mr J. Hopkinson of the Society of Antiquaries). The writer, however, does not seem to realise the probable origin of the 'umbrated charge', but suggests it comes from 'shadow' meaning ghost or phantom. [72]Also the Heralds helped depress the fortunes of the Painter-Stainers, who did regard themselves as practising, at best, art-painting ('Pictures by the life'), as well as more mundane sorts of painting. For their disputes, see W.A. Englefield, *The History of the Painter-Stainers' Company* (London, 1923), pp. 58-60; and for the Painter-Stainers as practisers of an *art*, see Sir William Monson, *Megalopsychy* (London, 1682), pp. 315-16. [73]*Elements of Armories*, p.5. Bolton also applies Pliny's account of the origin of painting to heraldry (p.60). [74]See, for example, John Ferne's strategies aligning heraldry with the liberal arts, *The Blazon of Gentrie* (London, 1586), pp.42-74. The commendatory verses set before Gwillim's *Display* all assume or imply heraldry to be an art. Whetstone, *An Heptameron of Civille Discourse* (London, 1582), virtually designates 'Armories' an eighth liberal art (sig. Siᵛ). [75]Discussed by Sara F. Stevenson, 'The Heraldic Ideal in England, 1560-1610', (unpublished M.Phil. thesis, University of London, 1972).

For all these reasons it acted as a conservative force where thinking about painting was concerned.

Thus the native concept of painting is that it proceeds from a relatively unskilled outline drawing, which together with the under-painting provides the *adumbratio,* or shadow, to the skilled application of colours. The English tradition has no place, no words, for artistic drawing, for composition, perspective, design and chiaroscuro, and its survival is why writers so often speak of a painter 'shaddowing' a picture when they simply mean that he is painting it, not that he is using devices to give the illusion of depth and solidity. Barnabe Barnes, for example, in madrigall 4 of *Parthenophil and Parthenophe* (London, 1593) says the painter Zeuxis 'gan with vermil, gold, white, and sable / To shadow forth' the 'mistresse pourtraict'; and Robert Cawdrey, in 1604, defines an emblem as 'a picture shadowing out some thing to be learned'.[76]

This long excursus may appear to have been unnecessary when one considers the typical flat Elizabethan portrait which, whether relatively crude (as are, for example, many of those currently on display in the long gallery at Montacute) or skilful (such as the Tate Gallery's 'Portrait of a Lady'; see Plate 1) depended on outline, pattern and colour for its effect, not on perspective and modelling. Such pictorial tastes are confirmed again and again in portraits of the Queen, both miniature and large scale; Elizabeth was one of the few individuals to be in a position to choose her style, for the Royal Collection offered her an alternative style embodied most notably in Holbein's work, so that her own portraits, which are flat and deco-rative in character, must have followed from her preferences. Hilliard's miniatures too, like his written views, show a taste for limning that plays down shadowing; he writes of his liking, understood by and shared with the Queen, for a sitter in a light which minimises shadows, and inveighs against those painters who deploy shadows too freely and strongly.[77] His career, ending impoverished and out of fashion, is evidence of an English change of taste towards the more shadowed miniatures of Isaac Oliver (see Plate 3).

But I have deliberately stressed the verbal counterpart to the visual material in order to suggest a prevalent way of thinking about as well as looking at pictures, because verbal contrasts help measure the impact of a new pictorial art which used chiaroscuro and perspective. Professor C.M. Robertson saw the force of this when he suggested that the introduction of shadows into the Elizabethans' experience of painting was as revolutionary as the discovery of shadows by Greek painters.[78]

[76] *Parthenophil and Parthenophe,* edited by V.A. Doyno (Carbondale and Edwardsville, 1971), p.11; Cawdrey, *A Table Alphabeticall* (London, 1604), sig. D3ᵛ. [77] The Arte of Limning', p.29. [78] *A History of Greek Painting,* 2 vols (Cambridge, 1976), I, 425-26.

Certainly the excitement pictorial art caused English writers in the last two decades of the sixteenth century is often prompted by the miraculous effects of shadow and perspective, as in Drayton's account of the paintings in the chamber prepared for Mortimer by the Queen. 'Heere *Phoebus* clipping *Hiacynthus* stood':

> Here lyes his Lute, his Quiver, and his bowe,
> His golden mantle on the greene-spred ground,
> That from the things themselves none could them know,
> The sledge so shadowed, still seem'd to rebound,
> Th'wound beeing made, yet still to make a wound.[79]

This is the version in *Mortimeriados* (1595); Drayton's revision of the description in *The Barons Warres* (1603), more studied, more informed, less present — it is cast in the past tense — and less involving to the reader, is a measure of his rather naively enthusiastic earlier response. By 1603 he is used to such pictorial effects, almost slightly ashamed of the way he had been bowled over by pictorial miracles some eight years earlier.

Landscapes amazed spectators with their 'shaddow and projection', producing such life-like but illusionist results, making

> . . .that which is low seeme high,
> That's shallow deepe, small great, and farre that's nigh.[80]

Probably Fulke Greville has landscape-painting in mind when he indicts pictorial art: *'Shadowes and distance do abuse the eye.'*[81] And in a prefatory verse to Gwillim's *Display of Heraldrie* (1611), Anthony Gibson praises Gwillim's work for being like a 'curious *Lant-schape'*, in bringing heraldry to life by means of *'shade* and *light'*.

If we wonder at the Elizabethans' capacity for wonder when faced by a genre so familiar today, one glance at a landscape-engraving after Breughel (see Plate 4) compared with the little notational signs of landscape in the woodcuts to *The Shepheardes Calender* (1579), confirms the power of the new art's illusion.[82] Literary sources, however influential, cannot entirely account for the impact in 1586 of 'a perfect peece of *Lantskip'*, with its

> goodly vallies: woodes hye, and decked with stately trees (some toppes

[79]*The Works of Michael Drayton*, edited by J.W. Hebel, 5 vols (Oxford, 1931-41), I,375, ll. 2325-29; commentary edited by J.W. Hebel, K. Tillotson, B.H. Newdigate, V,43. [80]Verses by E. Heyward prefacing *The Barons Warres;* Drayton, *Works,* II, 7. [81]*Cælica,* sonnet 55; *Poems and Dramas,* edited by G. Bullough, 2 vols (Edinburgh and London, n.d.) I, 106. [82]Reproduced in *Poetical Works,* edited by Smith and de Selincourt.

whereof the winde seemeth to wreathe and turne at one side) then goodly rivers, hye wayes, and walkes, large situate and hie climbing hills and mountaynes, far prospectes of Cities, Steeples, and towres, ships sayling on seas, and waves blowne up aloft, the element cleere, fayre, and temperate, with some shining beames shadowing, and spreading over all these.[83]

Perhaps the genre which more than any other brought home the power of illusionist art was the anamorphosis, the 'perspective-picture' as the Elizabethans called it, exemplified by the distorted skull in Holbein's 'The Ambassadors' (in the National Gallery), and by Scrots's anamorphosing portrait of Edward VI (in the National Portrait Gallery).[84] Drayton, for example, goes on from the passage quoted earlier to describe the image of Io which was

> By prospective devis'd that looking nowe,
> Shee seem'd a Mayden, then againe a Cowe.

(In 1603 Drayton has second thoughts about a whole-hearted accept-ance of the virtuoso trick:

> So done, that the Beholders oft mistooke
> Themselves; to some, that one way did allow
> A Womans likenesse, th'other way, a Cow.)

Numbers of allusions to perspective-pictures occur in Shakespeare's and Chapman's work, and elsewhere.[85] Such images must have played

[83] Angel Daye, *The English Secretorie*, p.44. One can find a partial parallel in Agrippa's *Of the Vanitie and uncertaintie of Artes and Sciences*, translated by James Sanford (London, 1569), fol.38r, describing the art of the chorographer; but there is no mention of the painter, or his light and shade effects. There is, however, a case for arguing that the very popular 'science' of cosmography cultivated the Englishman's response to the depiction of space, preparing the way for the impact of illusionist art; see, for example, Stephen Muenster's *Cosmographie,* augmented etc. by François de Belleforest (Paris, 1575). And visually, works on perspective, surveying and the art of war probably disseminated the notion of illusionist art, since their illustrations incorporated often quite striking landscapes. See, for example, those used by Walter Rivius (or Ryff) in Book IV of his *Architectura* (Nuremberg, 1547); Jean Cousin's 'grand paisage' in his *Livre de perspective* (Paris, 1561), sig. Miir; and the landscape attributed to Jost Amman showing a cosmographer on a hill viewing a town below him, with mountains and the sea, presumably executed for a work on surveying (BM, Prints and Drawings, 1952-4-5-209). The Appendix below demonstrates some of the distribution and ownership of works on perspective in England 1580-1630. [84] This genre has received considerable attention in recent years. For a discussion of it, see Jurgis Baltrušaitis, *Anamorphoses ou magie artificielle des effets merveilleux* (Paris, 1969), translated by W.J. Strachan as *Anamorphic Art* (Cambridge, 1977). [85] Cited by Drayton's editors, *Works*, V,43. Other examples: George Hakewill, *The Vanitie of the eie* (Oxford, 1608), p.81; Drummond of Hawthornden, printed in *The History of Scotland* (London, 1655), p.250. A useful discussion of 'The Concept and Metaphor of Perspective' is that by Claudio Guillén, in *Comparatists at Work*, edited by Stephen G. Nichols and Richard Vowles

an important, if rather crude, part in widening the pictorial experience of the English, making them realise the effects which painting could produce, and reflect on the mechanisms that caused the miraculous result.

The term 'perspective' becomes quite widely used in the last two decades of the sixteenth century, not in the old context of 'perspectiva communis', the science of optics based on Euclid, but as a sign of 'quello ch'e dipintori oggi dicono prospettiva'.[86] 'And perspective it is best Painters art': Shakespeare's line in sonnet 24 is very English in that he clearly knows that perspective is responsible for amazing effects — he recognises it when he sees it — but he does not know what it entails. Sir John Harington draws his reader's attention to a feature of his book's illustrations 'which every one (haply), will not observe, namely, the perspective in every picture'. This is, incidentally, a telling comment on the English spectator's naivety or ignorance, at any rate in Harington's eyes. But what is curious is the way he goes on: 'For the personages of men, the shapes of horses, and such like, are made large at the bottome, and lesser upward, as if you were to behold all the same in a plaine, that which is nearest seemes greatest, and the fardest, shewes smallest, which is the chiefe art in picture.'[87] Even this aficionado of painting,[88] who offered his readers engraved illustrations of a quality way above the English norm of the 1590s, did not have a working definition of perspective.

So new to England was perspective that even an artist, the author of BL, Sloane MS 536 (of the late sixteenth century), cannot find a satisfactory wording by which to describe it, although he can work with it. He first equates it with 'Sciographia'. Then, on fol.1v, he defines it as

> the delineation of that appearance of bodies and figures which semeth to vary from the trew proportion by reason of distance of place.

Later, on fol.8r, he tries again:

> Perspective is the arte or skille to expresse in due proportion the apparent

(Waltham, Mass., Toronto and London, 1968), pp.28-90; reprinted in *Literature as System* (Princeton, 1971). [86]This remark from Brunelleschi's *Vita* is picked up by M. Boscovits, 'Contributions to Fifteenth-Century Italian Art Theory: Part I', *Acta Historiae Artium*, 8 (1962), 241-60. A lucid account of this difficult topic, and one that includes both a technical and a historical survey, is that by Professor B.A.R. Carter in the *Oxford Companion to Art*, edited by Harold Osborne (Oxford, 1970). See also A. Flocon and R. Taton, *La Perspective* (Paris, 1963). For a recent account in a literary context, see Ernest B. Gilman, *The Curious Perspective: Literary and Pictorial Wit in the Seventeenth Century* (New Haven and London, 1978), ch.1. [87]*Orlando Furioso*, 'An advertisement to the Reader . . . of some things to be observed . . . with the use of the Pictures', sig. Alr. [88]See his notes on painters at the end of Book XXXIII, 277-78,

shewe of figures caused by reason of theire distance from the eye of the beholder.

But even this will not do. On fol.13ʳ he considers it again, this time in the terms of Aristotelian method, that is, its subject and aim. The first is

the appearance or shape of figures which is caused by reason of theire distance for figures and bodyes a farr of make shew of an other shape and proportion then thei are indeede.

The end of

this skill is rightly and proportionably to expresse that varietie of shewes accordinge to the diversitie of the distance and position.[89]

Since considerable numbers of copies of perspective treatises and architectural treatises (many of which discuss perspective) can be traced in England at the time,[90] the English problem in defining it is in some ways surprising, and must surely count as one more indication of Englishmen's limited experience of pictures. It is also a sign of the English uneasiness that perspective is a means, as Hilliard neatly put it, by falsehood to express truth.[91] What attitude was to be taken towards a technique that so dramatically separated appearance and reality, things as they truly are and things as they appear to be? However, the point at issue here is not that an English writer such as Harington fails to understand the technicalities of the difficult skill of perspective, but that in the 1580s and after such men register 'perspective' as a feature new in their experience of pictorial art, and one that produces amazing results, such as the Escher-like diagram by Jean Cousin that figures in a book to be found in several English libraries of the time (see Plate 5, and Appendix). Even when writers use the word as a metaphor, and confuse it with other meanings such as 'prospective glass' (that is, refracting telescope), its link with *perspectiva artificialis* remains clear.[92]

Allusions to pictorial effects produced by light and shade are harder to link with some sort of visual experience, for they are always likely to have a literary source. For example, E.K.'s citation of the pleasing effects worked by contrasts of light and dark in landscapes, in his

where, following Ariosto, he not only mentions Leonardo, Mantegna, Giovanni Bellini, Michelangelo, Raphael, Sebastiano del Piombo (adding Hilliard), but briefly describes Michelangelo's 'Battle of Cascina'. [89]This manuscript is discussed by the Ogdens in *English Taste in Landscape in the Seventeenth Century*, ch.1. [90]See the Appendix. [91]'The Arte of Limning', p.20. [92]See, for example, the metaphorical use by Samuel Daniel in *A Defence of Rhyme*, in *Elizabethan Critical Essays*, II, 376.

introduction to Spenser's *Shepheardes Calender* (1579), sounds as though it might be based on pictures:

> . . . as in most exquisite pictures they use to blaze and portraict not onely the daintie lineaments of beautye, but also rounde about it to shadow the rude thickets and craggy clifts, that by the basenesse of such parts, more excellency may accrew to the principall.

But the source is most probably a passage in Paolo Pino's *Dialogo di pittura* (Venice, 1548), which also found its way into Philip Du Plessis Mornay's *De la vérité de la religion chrestienne* (Antwerp, 1581), and thence into Sidney and Golding's translation, *A woorke concerning the trewnesse of the Christian religion* (1587).[93] And anyway the aesthetics of contrast form a tradition reaching back to antiquity, overlapping with Platonism's play on light and dark, as well as Christianity.[94] In addition Pliny describes the skill of classical painters in using white and black to produce lifelikeness in a picture.[95]

Nonetheless, some references to light and shade are undoubtedly based on something seen as well as conceptually understood. In Sidney, probably uniquely among the Elizabethans, one finds both the concept and the visual experience. Thus, in sonnet 7 of *Astrophel and Stella* he writes:

> When Nature made her chiefe worke, *Stella's* eyes,
> In colour blacke, why wrapt she beames so bright?
> Would she in beamie blacke, like painter wise,
> Frame daintiest lustre, mixt of shades and light?

This apparently stock Elizabethan conceit is no commonplace, but seems to allude to a remark of Alberti's, in Book II of his treatise on painting, where he says that the 'composition of white and black has such power that, when skilfully carried out, it can express in painting brilliant surfaces of gold and silver and glass'.[96] However, Sidney's interest in Alberti was concurrent with his interest in the painter's techniques. When Philisides describes Philoclea's knees, in the *Arcadia*:

> The knottes of joy, the gemmes of love,

[93]See Pino's *Dialogo*, fol.29ᵛ. I am grateful to C.M. Kauffmann and R. Lightbown of the Victoria and Albert Museum for pointing this out to me. Dr Kauffmann observed that I could have deduced it from E.H. Gombrich's essay on landscape, in *Norm and Form* (London, 1966), pp.107-21. [94]See, for example, H.V.S. Ogden, 'The Principles of Variety and Contrast in Seventeenth-Century Aesthetics, and Milton's Poetry', *JHI*, 10 (1949), 159-82; and J.A. Mazzeo, 'Light Metaphysics, Dante's "Convivio" and the Letter to Can Grande della Scala', *Traditio*, 14 (1958), 191-229. [95]*Naturall Historie*, translated by Holland, II, 547. [96]*Alberti*, edited by Grayson, p.91.

> Whose motion makes all graces move.
> Whose bought incav'd doth yeeld such sight,
> Like cunning Painter shadowing white

the passage, like that from *Astrophel and Stella,* reflects the knowledge that a picture may indeed depend more on shadows than on glittering colour to give if life.[97]

Sidney is alert, too, to the chiaroscuro of landscape. Thus he describes the setting of the star-shaped lodge in the *Arcadia:*

> Truly a place for pleasantness, not unfit to flatter solitariness, for, it being set upon such an insensible rising of the ground, as you are come to a pretty height before almost you perceive that you ascend, it gives the eye lordship over a good large circuit, which according to the nature of the country, being diversified between hills and dales, woods and plains, one place more clear, another more darksome, it seems a pleasant picture of nature, with lovely lightsomeness and artificial shadows.[98]

That we are not dealing purely with literary and conceptual fashions is confirmed by Edward Norgate, who remarks, in the 1620s, that '*Chiar-Oscuro*' is 'a Species of Limming frequent in Italy but a stranger in England', both 'a strange name' and a strange thing.[99]

It is the novelty of the combined effects of perspective and chiaroscuro in England in the 1590s that makes the Elizabethans newly conscious of the astonishing capacities of art for illusion, and leads them to bring new vitality to the old clichés of lifelike art, as in Nashe's 'summer banketting house', the floor of which was painted 'with the beautifullest flowers that ever mans eie admired; which so lineally [lively?] were delineated that he that viewd them a farre off and had not directly stood poaringly over them, would have sworn they had lived in deede'.[100] Renaissance techniques of painting are, I would argue, the source of their praise, even when the devices the writers describe are as likely to be found in tapestry as painting, or in a passage by Philostratus:[101]

> For much imaginary work was there;
> Conceit deceitful, so compact, so kind,
> That for Achilles' image stood his spear,

[97]*The Poems of Sir Philip Sidney,* edited by W. Ringler (Oxford, 1962), p.89. Ringler glosses 'bought incav'd' as 'the inward-bent curve behind the knee'. For shadows and life in a painting, see *Arcadia* in *The Complete Works of Sir Philip Sidney,* edited by A. Feuillerat, 4 vols (reprinted Cambridge, 1965), I, 333. Also compare *Arcadia,* p.318: Zelmane's words, painting out her mind, 'served as a shadow, to make the picture more lively and sensible'. [98]*Arcadia,* in *Works,* I, 91. [99]*Miniatura,* pp. 5, 60. [100]*The Unfortunate Traveller, Works,* I, 283. [101]E.H. Gombrich points out the relevance of Philostratus to the passage in *Art and Illusion* (London, 1960), pp. 176-77, 351.

> Grip'd in an armed hand; himself, behind
> Was left unseen, save to the eye of mind:
> A hand, a foot, a face, a leg, a head,
> Stood for the whole to be imagined.[102]

'Conceit deceitful' is just the sort of phrase to be prompted by the pictorial techniques new to the Elizabethans' visual experience.

The pictorial miracle for the Elizabethans can be summed up in the one word 'shadows', which could already mean 'paintings' because of the old idea of the painter proceeding from adumbration to colours. The coincidence of this old sense with the new understanding of the 'shadows' to be found in pictures (that is, light and dark employed in pictorial space organised by perspective) was in fact quite fortuitous. The first sense does not lead to the second. But the existence of the first in verbal terms prepared the writer to be impressed by the second, particularly as there was a further pun on 'shadow' meaning a picture. A picture was a 'shadow' because it was not the 'substance', that is to say the object which it pretended to be. Enemies of art were accustomed to belittle pictures by calling them 'feigned shadows' or 'painted shadows'. Now, in the 1590s, writers see that feigned shadows are precisely what give the good picture substance, for the reason that they add extreme lifelikeness to the artist's imaginative grasp of his subject. The implications of this for English writers I discuss in Chapter III. What I want to draw attention to here is how the writer, both through the eye and by the word, was being conditioned to regard shadows as a picture's excellence.

To recapitulate: what the pictorial miracle leads to is the reaction 'how lifelike', which admittedly is no more than Englishmen had said earlier in the century, or even in Chaucer's day:

> Wel koude he peynten lifly that it wroghte;
> With many a floryn he the hewes boghte.[103]

But that earlier Englishmen had said 'how lifelike', seeing lifelikeness in lively colours, and that men in the 1580s and 1590s continue to say 'how lifelike', now struck by the capacities of perspective and chiaroscuro, is immaterial, since lifelikeness is all relative; the illusionist image placed next to the flat one does indeed seem to possess amazing verisimilitude.

Of course, to claim that 'how lifelike' is not, at this period, simply a cliché, means accepting three postulates. The first is that most Englishmen's ideas of painting were relatively conservative and

[102]*Lucrece*, ll.1422-28. The passage has recently been discussed by S. Clark Hulse, 'A Piece of Skilful Painting in Shakespeare's *Lucrece*', *Shakespeare Survey*, 31 (1978), 13-22. [103]*The Knight's Tale*, l.2087.

provincial. In the second place, few men had much chance to see paintings of a very high quality, since, with the exception of Hilliard, England did not possess painters to rank with those on the Continent; admirable though the work of, for instance, Scrots, Gower and Segar may be, it cannot compare with that of, say, Dürer or Titian. Thirdly, Englishmen were accustomed to paintings, good or bad, which did not use shadows to create the illusion of reality. If one grants these points, then it is easy to see that men could be deeply struck by certain sorts of painting.

In further support of the first postulate another kind of evidence may be adduced, that of the new fashion for emblems and the old fashion for allegory, both of which must have affected men's expectations of images, and their pictorial tastes.[104] Emblems had long been known in England, in the shape, for example, of heraldic devices, and what might be called an emblematic expectation of visual images was already entrenched; a picture was regarded first and last as a vehicle of meaning. In the late 1580s, the fashion for emblem books began to gather momentum in England (Daniel's translation, *The Woorthy Tract of Paulus Jovius* appeared in 1585, and Whitney's *A Choice of Emblemes* in Leyden in 1586), ironically at the same time as, I have argued, a certain number of men began to take note of art-paintings. This twin fashion incidentally helped to give the visual image considerable charisma by allowing it, potentially, the truth of meaning and the truth of lifelikeness. And the taste for the one does not necessarily preclude the taste for the other. Sidney, the one Englishman who obviously did have an informed zest for art-paintings, is also perhaps the most sophisticated in his handling of emblems, as in the wonderful description of Amphialus' and Phalantus' horses and their furniture in the *Arcadia*.[105] But Sidney is the exception, and as a general rule the emblem taste, which unlike the taste for paintings bridged all classes, positively encouraged men *not* to think about the art of painting, since it invited them to regard a picture as an emblem shadowing out some thing to be learnt. Meaning was all-important, aesthetic considerations negligible. In fact, the existence of an actual visual image was not even necessary, for in the early editions of the first emblem book, Alciati's *Emblematum Liber* (originally published in Augsburg, 1531), by no means all the emblems were illustrated, so mental and unvisual was the form essentially. Granted that the later, illustrated emblem books usefully habituated readers to pictures, at the same time they did the arts of picture a disservice by inhibiting any curiosity about visual experience.

[104]See Rosemary Freeman, *English Emblem Books* (London, 1948). [105]Katherine Duncan-Jones discusses such passages very fully in 'Sidney's Pictorial Imagination'. As for why Sidney was so exceptional see her thesis and John Buxton's *Sir Philip Sidney* (London, 1954).

The conceptual way of regarding a visual image which was encouraged by emblems retarded in yet another respect the development of art-appreciation. This can be illustrated by the example of landscape, a genre of art which really did manage to impress English spectators as new, deceptively lifelike and delightful to the eye, the sight being 'so bewitched that its then most delighted, when tis most deceived, by shadowings, and landskips, and in mistaking counterfaits for truths'.[106] It very quickly developed new symbolic meanings or resuscitated old ones; for example, it could symbolise the world, and hence creation;[107] it could represent history, because it brought distant things close;[108] it might be the sign of a world resonant to man, or of one indifferent to him.[109] It could become an emblem: a gentleman 'tooke for his device Landskip, as they call it, and solitarie Mountaines, with TUTI MONTES, TUTUM SILENTIUM'.[110] Thus landscape gained considerably as an *idea*, so that to some extent the actual appearance of landscape paintings and engravings mattered commensurately less. One can see how if men's minds were full of the richness of the concept of a certain kind of painting, say landscape, or portraiture, they would tend to overlook the faults of actual pictures, finding in them the manifestation of the pattern, the type.

The relatively new craze for the emblem overlapped with the traditional use of pictures for allegory, which tended, in the sixteenth century in England, to deter the spectator from looking at a picture for its aesthetic qualities. There are, naturally, honourable exceptions of paintings which combine allegory with a high standard of execution, like the foreigner Eworth's delightful portrait of Sir John Luttrell of 1550;[111] and of course there is no intrinsic incompatibility, even in England, between allegory and painting of a high quality; witness Rubens's Whitehall ceiling. But that was painted in a different climate of patronage, and after the revolution in artistic attitudes which it is tempting to associate particularly with Inigo Jones. Before 1600 the norm is art for allegory's sake.

Portraits of the Queen were to be portraits of true majesty; 'The Picture of a Royall Princesse, moste ritchly and lively set foorth',[112]

[106]Hakewill, *The Vanitie of the eie*, p.84. Compare Norgate: 'Lanscape is nothing but Deceptive visions, a kind of cousning or cheating your owne Eyes, by your owne consent and assistance,' *Miniatura*, p.51. [107]Du Bartas, 'The Seaventh Day of the first Weeke' (1578), in *Bartas His Devine Weekes and Works*, translated by J. Sylvester (London, 1605), edited by Susan Snyder, 2 vols (Oxford, 1979), I, 294-96. K. Scoular, *Natural Magic* (Oxford, 1965), p.163, gives other examples. [108]Drayton, *Polyolbion*, 'To the Generall Reader', *Works*, IV, sig. V*: ascend to the top of an easy hill, 'from whose height thou mai'st behold both the old and later times, as in thy prospect, lying farre under thee'. [109]For example, Sidney's double sestina, 'Yee Goteheard Gods', *Poems*, p.111. [110]William Camden, *Remaines of a greater worke, Concerning Britaine* (London, 1605), p.168. [111]One version is in the Courtauld Gallery, illustrated in Strong, *The English Icon*, p.86. [112]Whetstone, *An Heptameron*, sig. Miiiʳ.

was what her loyal subjects were prepared to find, regardless of the quality of the painting they saw. As her circulated portraits might almost be regarded as religious icons, they had a powerful effect on what men looked for in a portrait; and as her circulated portraits tended to sink in quality — orders were issued in 1563 and again later prohibiting all but one or two skilled painters from setting out her picture[113] — they cannot have done anything for the cause of art. Even portraits of the quality of the 'Sieve' and the 'Ermine' portraits encourage one to read as much as to look.[114]

A curious insight into the relation between word and visual image in allegorical pictures can be gained from the detailed programme for a series of paintings set out in BL, Sloane MSS 1041, 1062, 1063, 1082, 1096 and 1169 dating from c.1580.[115] It contains many contemporary allusions (such as those to the vile N.S., the Roman Catholic Nicholas Sanders), the writer's own compilation of iconographical details, and reads like several pictures in which the author rewards his allies and punishes his enemies. The human beings are to be recognised by their emblematic attributes or by a label; only occasionally is there a different kind of instruction, as when the corners of a certain Selimus' eyes are to be made 'smirkynge like the duke of Guyse'.[116] More typical is the direction to draw Venus 'as Chaucer wryteth of her'.[117] If it were not for the odd reference to a particular image, or to 'land-skipps', and the fact that the writer actually includes some illustrations, one might imagine that the pictures were only ever intended to be verbal, like those of Robert Holcot long before;[118] indeed, one can find plenty of evidence elsewhere that an English preference survived for the written word over the visual image, as though the latter still, in some men's eyes, suffered from the plebeian associations of the *Biblia Pauperum*, the visual image used to teach the illiterate.

The persistence of such elaborate literary schemes and their visual counterparts well into the second half of the sixteenth century again helps account for the acclaim which greeted anything more modern. If you were used to an image of Venus as Chaucer writes of her, that is, in the iconographical tradition to which his descriptions belong,[119] or to pictures so totally lacking in spatial organisation as woodcuts showing Venus with a cithern and a comb, even a second- or third-rate Renaissance picture of Venus, or Diana, or a 'perspective' of one sort or another, must have looked amazingly lifelike.

Emblems and pictorial allegories would have had less effect on the

[113]See Auerbach, *Tudor Artists*, p.103. [114]Illustrated in Strong, *The English Icon*, pp.157, 219. [115]I owe this reference to the late Mr Edward Croft-Murray. [116]BL, Sloane MS 1096, fol.11ʳ. [117]BL, Sloane MS 1041, fol.11ʳ. [118]See Beryl Smalley, 'Robert Holcot O.P.', *Archivum Fratrum Praedicatorum*, 26 (1956), 5-97. [119]Discussed by Meg Twycross, *The Medieval Anadyomene*, Medium AEvum Monographs 9 (Oxford, 1972).

responses of English spectators if there had been a wider acquaintance
with paintings of an acknowledged quality: the second of the three
points postulated earlier. But on the question of how much familiarity
Englishmen had with such paintings, two obvious factors have always
tended to be overlooked. By culling all possible examples of a reason-
ably good standard of painting and sculpture from all possible
sources — inventories, letters, and artefacts still in existence — it is
possible to gain the impression that England, after all, was not so badly
off for pieces of good art. But exemplars of the better sorts of art were
confined to noblemen's collections, and thus only accessible to out-
siders and protégés on an occasional basis. There is little evidence that
good prints were available in England,[120] and all but very good prints
are, as Hazlitt says, 'but hints, loose memorandums, outlines in little of
what the painter has done'.[121]

The other factor that tends to be ignored is that a painting is unique;
it cannot be duplicated. How long does one carry around the detailed
memory of a painting (or a sculpture) glimpsed once and once only?
Hazlitt, again, beautifully develops some implications of a picture's
uniqueness. While that uniqueness is a drawback in one way,

> in another point of view, [it] operates probably as an advantage, by making
> the sight of a fine original picture an event so much the more memorable,
> and the impression so much the deeper. A visit to a genuine Collection is
> like going a pilgrimage — it is an act of devotion performed at the shrine of
> Art! It is as if there were but one copy of a book in the world, locked up in
> some curious casket, which, by special favour, we had been permitted to
> open, and peruse (as we must) with unaccustomed relish. The words would

[120]This is a difficult field which has not been systematically researched; it is extremely
hard to assess the circulation of engravings. Obviously many were in circulation as
patterns among tapestry-makers, goldsmiths, architects and so forth; such engravings
were likely to derive from the Low Countries. The Hatfield tapestries of the seasons, for
example, are based on designs by Martin de Vos. The influence of Continental pattern-
books is discussed by James Lees-Milne in *Tudor Renaissance* (London, 1951), ch.7. A.
Hind, *Engraving in England*, Part I (Cambridge, 1952), has much to say about Con-
tinental models. By 1577 Sir Thomas Smith or his artist had access to engravings of 'The
story of Cupid and Psyche' by Agostino Veneziano and the Master of the Die after
Michael Coxcie (illustrated in Croft-Murray, *Decorative Painting in England*, I, Plate
39). Carl Winter, *Elizabethan Miniatures* (Harmondsworth, 1943), points out that
Hilliard adapts the stock scenery used by Dürer in a number of engravings and wood-
cuts, and that the composition of Isaac Oliver's 'Portrait of a Young Man Said to Be Sir
Philip Sidney' is based upon a reversal of Dürer's engraving, 'The Madonna with the
Pear' (pp.25,26). Peacham in *The Gentlemans Exercise* (London, 1612), p.47, says that
engravings by Dürer are hard to obtain, but that those by Goltzius are to be had in
Popeshead Alley. In *The Compleat Gentleman* (London, 1622), p.109, he adds that 'the
peeces of *Michel Angelo* are rare and very hard to come by'. William Burton, brother of
Robert, talks about collecting and enjoying 'curious cuts' when he was younger, that is,
in the early years of the seventeenth century (manuscript printed by J. Nichols, *History
and Antiquities of Leicester*, 4 vols (London, 1795-1815),III, 489-90). [121]*Sketches of the
Principal Picture-Galleries in England* (London, 1824), p.5.

in that case leave stings in the mind of the reader, and every letter appear of gold.[122]

Hazlitt writes with a cultivated eye; the eyes of all but a very small handful of Elizabethans were uncultivated, in the sense that they were uneducated in looking at pictures, and their idea of a 'fine original picture' would probably not have coincided with his. Nonetheless, the psychological effect Hazlitt describes is essentially true for the naive as well as for the sophisticated admirer of pictures. The rare experience could keep the reaction 'how lifelike' as a live response in the period of twenty to thirty years under discussion here; and that same rarity caused the pictorial features new to the spectator to leave 'stings in the mind'.

The third postulate, that of an English tradition for flat as opposed to illusionistically shadowed painting, has already been discussed. However, one more aspect of the question needs to be mentioned, since it might be objected that the presence of excellent shadowed portraits in England, such as Antonio Mor's of Queen Mary and, pre-eminently, those of Holbein 'the incomparable', is the sign of a contrary taste.[123] But could a small number of such paintings, held in the Royal Collections and those of a small élite, ever habituate the visual tastes of a nation to a new style in paintings? Apart from a couple of references by Hilliard and Haydocke, Holbein's name is not mentioned until the fashion for collecting portraits by him begins in the seventeenth century, the Countess of Bedford competing with Arundel to lay her hands on choice pieces by him. For unlike Dürer, whose name is quite frequently cited by the Elizabethans to exemplify a great artist, he published no treatise on art which would spread his fame, and he was not eulogised in print, as was Dürer by Erasmus.[124] Moreover, he seems to have been affected by a swing in taste after the death of Henry VIII, for Lucy, Countess of Bedford says that some of the paintings she has collected 'I found in obscure places, and gentleman's houses, that, because they wear old, made no reckoning of them'.[125] In other words, pictures collected in Henry VIII's day seem to have gone out of fashion with the descendants of the collectors, as is hinted at also by a remark in Haydocke's preface to his translation of Lomazzo. Rather than developing out of pictures already in the country, the later Elizabethan taste for shadowed paintings seems to

[122]*Sketches*, p.6. [123]*Miniatura*, p.39. [124]See E. Panofsky, 'Erasmus and the Visual Arts', *JWCI*, 32 (1969), 200-27. [125]*The Private Correspondence of Jane Lady Cornwallis, 1613-1644*, edited by Lord Braybrooke (London, 1842), p.51. Haydocke, too, suggests such a swing in taste, as A. Moffat has pointed out, 'Lomazzo's Treatises', p.33. As for Antonio Mor's splendid portrait of Queen Mary in its several versions (Strong, *The English Icon*, p.118), it was scarcely likely to be favoured in Elizabeth's reign.

have followed the influx of painters from the Low Countries in the early 1570s, the result of Spanish persecution in the Netherlands.[126]

An interesting phenomenon that accompanied the growing English enthusiasm for illusionist pictures, and one of importance in the context of the interaction between poetry and painting, is the explosion of literary allusions to Pliny's anecdotes of painters, particularly to the stories of birds, animals and even men deceived by *trompe l'œil* effects. Such allusions litter the prefaces of the period, as in the following:

> Zeuxes endevouring to paint excellentlie, made Grapes in shewe so naturall, that presenting them to view men were deceaved with their shapes and the birdes with their cullours. When *Apelles* drew *Venus* (though the shew of beautie seemed woonderful) he daunted not in his workmanship, because he knew his cunning excellent. If in penning I were as skilful as the least of these in painting: I should neither faint to present a discourse to Alexander, nor to tell a tale to a Philosopher.[127]

Although such anecdotes can occasionally be found in English before 1578, it seems to have been Lyly who, using Pliny's account of painting as a kind of source, popularised painterly allusions and conceits. Some of these occur in the prefatory matter to *Euphues* (*c*.1578), such as:

> For as every Paynter that shadoweth a man in all his parts giveth every peece his just proporcion, so he that disciphereth the qualitie of the mynde, ought aswell to shew every humor in his kynde, as the other doth every part in his colour.

And, 'we commonly see that a black ground doth best beseme a white counterfeit'. But in *Euphues and his England* (1580), ornamentation of Pliny's kind of anecdote is to be found widely spread through the story as well, becoming an indispensable part of Lyly's witty and courtly style. The allusions are often a sign of his desperate desire to compliment his Queen, and of his conviction that her regime is a revival of classical glory:

> Besides that, *Alexander* must be painted of none but *Apelles,* nor engraven of any but *Lisippus,* nor our *Elizabeth* set forth of every one that would in duety, which are all, but of those that can in skyll, which are few.[128]

(Ironic, since Lyly sees the orders concerning the Queen's portrait as a sign of classical splendour recreated, whereas they were merely

[126]For the specific character of some of this art, see John Summerson, *Architecture in Britain,* pp.53-54. [127]This is from Angel Daye's *The English Secretorie* of 1586. Other examples include A. Saker, *Narbonus* (London, 1580); Thomas Howell, *His Devises* (London, 1581); and several works by Greene and by Lodge. [128]*Works,* II, 38.

promulgated to remedy the low standard of many of her circulated portraits.) His desire to please can lead to amusing results, as when in one of his major efforts he argues that he can only paint the back-view of Elizabeth, since the front-view defies description; Zeuxis,

> being in dispaire either by art to shadow [Venus], or by imagination to comprehend hir, he drew in a table picture a faire temple, the gates open, & *Venus* going in, so as nothing coulde be perceived but hir backe.[129]

Lyly's pleasure in ornamentation derived from pictures raises two interrelated questions. Firstly, it is curious that this enthusiasm for pictures should have occurred in a period which, overall, was characterised by iconoclasm.[130] Secondly, if he was so keen on what to him were subtle pictorial effects, why did he make use of imagined classical examples, rather than turning to any examples before his eyes? The issue is complicated, and the two points turn out to be linked. The way that he lavishes his art on his pictorial conceits suggests, surely correctly, that his own verbal artifice meant as much to him as the apparent focus of his interest and enthusiasm, the amazing visual artefact. He had not actually seen anything like, for example, the white ivory statue of Vulcan and the statue of Venus in jet that he describes at one point.[131] But 'skil and the love of skil do ever kisse',[132] and by praising, say, Apelles' art, Lyly is able to place on view his own skill in doing so.

As for the choice of examples that come from the classics (or appear to do so), iconoclasm was very likely a factor. In a society some of whose members could disapprove even of the portrait of a father, on the grounds that commemorative portraits had been the fount of idolatry,[133] there was a risk in referring to specific contemporary pictures, or specific painters, unless to a portrait of the Queen. And where were the figure-paintings to refer to, other than portraits? There was a limit to ingenuity, even Lyly's, in the play that could be made of the safe subject of Elizabeth's portraits by Hilliard. It was more secure to stay with the fabled painters and paintings and sculpture of antiquity,[134] and through these exemplars, which had the seal of approval in the shape of classical authority, to explore the qualities in

[129]*Works*, II, 211. [130]On iconoclasm in England, see J.R. Phillips, *The Reformation of Images: Destruction of Art in England, 1535-1660* (Berkeley, 1973). The attitude to images in the period of iconoclasm is illuminated by Ladner, 'The Concept of the Image'. [131]*Works*, II,102. [132]Chapman, *Poems*, edited by Bartlett, p.382, 1.49. [133]Attributed to, but probably not by, Nicholas Ridley, *A treatise. . . concerning images*, in *Works*, edited by H. Christmas (Cambridge, 1854), pp.81-96. [134]Thus George Pettie in *A Petite Pallace* (London, 1576), is able to tell the story of Pygmalion 'imbrasing, kissinge, and dallyinge' with his statue, and committing the crime not of idolatry but of having earlier gone in for 'rashe rayling against the florishinge feminine sex' (p.201).

painting which were found appealing.

Another reason for not moving beyond classical sources was that the English possessed no language of art-criticism beyond that provided by the classics. The paucity of terms we have seen, and the difficulty that Hoby in 1561, for example, had with certain concepts. In addition, men needed articulated critical structures for talking about and evaluating paintings. Italian art-criticism, so plentiful by the 1580s, had grown out of the classical discourse on painters, stimulated by the reality of Italy's vast artistic activity during the Renaissance.[135] Access to that contemporary art-criticism was not available to English writers; what would Vasari's references to pictures and painters have meant to either Spenser or Gabriel Harvey or to the dramatists?[136] Inevitably, therefore, the English writers, excited by some sort of pictorial visual experience, fell back on the classical models, particularly on those of Pliny and Plutarch.[137]

Moreover, good empirical reasons for doing so existed. In practical terms, both classical authors were accessible. On grounds of relevance, Pliny's well-known account of the evolution of painting matched Englishmen's experience. It began, he said as an art of outline, used one colour, then progressed to black and white and thence to many colours, to subtleties of light, shade and perspective, creating, finally, masterpieces of illusion.[138] This account broadly corresponded with the Englishman's discovery of pictures: from badly representational flat paintings to marvellous illusionist ones. Indeed, he might have been aware of a closer correspondence between the art Pliny described and the pictures he had seen. Old-fashioned painting used a heavy outline; each painting recapitulated its evolution, as it were, by proceeding from monochrome *adumbratio* to colours. It was overtaken by a new art which amazed by the way it handled light, shade and perspective, producing lifelike images which (almost) had the power to deceive the spectator.

At the same time Pliny, and even more Plutarch, distinguished between painters who crassly used their art to provide cheap effects, and those who aimed to content both the eye and the understanding. Translating the later parts of Pliny's account of painting, Philemon Holland often uses phrases which are just the same as those used to describe Renaissance and Mannerist painting: 'curious and exquisit' (*tantus diligentia*), 'curious workmanship'.[139] What difference was

[135]Part of the development is charted by M. Baxandall, *Giotto and the Orators;* see also his recent review-article in the *Times Literary Supplement,* 1 February 1980, p.111. [136]See also the Appendix, pp.72, 77 below. [137]Especially Pliny, *Natural History,* XXXV, and Plutarch, *Moralia,* 'How to study poetry'. [138]*Naturall Historie,* translated by Holland, II, 525. The same account is given by Philostratus the Elder, *Life of Apollonius of Tyana,* translated by F.C. Conybeare, 2 vols (London, 1912), I, 177-79. [139]The first phrase is p.534 in Holland's translation; compare Loeb edition, IX, 308. The second is in Holland, p.535; there is no exact equivalent in Pliny ('confessione

there between the arts Pliny described and the 'curious painting' which
the English knew was done in Europe? Both aimed to content the eye
of the judicious, rather than the eye of the ignorant, both employed the
same technical devices. Pliny even described landscapes, which the
English knew exemplified a skilled, illusionist painting — witness the
description of landscapes by Hakewill, Norgate and others.

Thus the Elizabethans' fondness for formulae based on Pliny and
Plutarch was not such a theoretical, or indeed foolish, taste as we
tend to assume. Classical authority harmonised with their limited
experience of contemporary and near-contemporary painting. They
followed Pliny, too, in praising virtuosity, particularly in illusion, and
the old cliché of the picture as real 'as if it lived indeed', had in
this test case of the Elizabethan spectators a foundation in what they
had actually seen, as well as in literary tradition. For today's critic,
illusionistic virtuosity is suspect as a criterion of artistic worth and of
course it is ultimately irrelevant to artistic quality. But for the late
sixteenth century in England, the aesthetically crude criterion of such
virtuosity was valuable to poets and dramatists, who made clever use
of it. Its value was twofold. First, writers extracted from the idea of the
supremely lifelike and judiciously executed picture a basis of theory
for their poetry. Second, by stressing illusion they expanded the scope
of their own art. The key in both respects was feigning.

artificum in liniis extremis palmam adeptus'; Loeb edition, IX, 310).

Chapter III

THAT poetry feigned, and that its excellence lay in its feigning, was a long-standing argument going back to the classics and, by the 1550s, vigorously updated in Italy: the most excellent sort of poet was he who, like Ovid describing impossible transformations, invented his subject-matter.[1] And because the doctrine of *ut pictura poesis* was widely accepted, what went for poetry also went for picture, as in Paolo Pino's remark that picture is essentially, like poetry, a matter of invention.[2] But in mid-sixteenth-century England and later, poetry had many opponents who denied its right to feign; if the role of poetry was traditionally to instruct and delight, they made the element of moral profit paramount. Poetry was deeply suspect to them because of its imitative and imaginative nature. Even its images of real-life objects pandered to the imagination and the senses; far worse were its images of non-existent objects. Correspondingly, contemporary poets tended to be described as workmen; their status as artists had not yet been accepted.

Sidney's *Apology*, written in the early 1580s, as well as being an exercise in the apologia for literature which were fashionable on the continent, performed a real function in answering the puritanical critics of poetry, setting it forth eloquently as an art of creation, and the poet a maker. But though Sidney put forward a programme for poetry in English, that programme still had to be realised. Both he in his arguments, and after him the poets who established the right of poetry to feign, drew on the status of painting.

This is a paradox that calls for some comment. For how could painting, only arguably recognized as an art in England, with relatively few exemplars to demonstrate its excellence, and suspect because of the climate of iconoclasm, conceivably have aided the art of poetry? I think the reasons are as follows.

England was so deficient in the suspect type of figure-painting that art-painting, the 'curious art' which linguistically the English had some difficulty in distinguishing from other sorts of painting, by its absence escaped the sort of censure levelled at practising poets. Added to this, I would argue that the state of painting in England, a state so vividly deplored by Haydocke in his preface to Lomazzo, was actually helpful to the writers. The generally low level made possible the enthusiastic

[1]See above, ch. I, note 17. [2]See above, ch.I, note 18; Pino goes on to praise invention highly.

response to another, higher, standard of painting, the scarcity of excellent paintings ensuring that the response did not fade away into the light of common day. The enthusiasm, meanwhile, was a powerful source of energy which could be channelled into writing about the visual arts in literature.

Another factor was that men's views about painting were likely, for much of the time, to be formed on quite theoretical grounds. The question of painting's worth was not to be resolved by looking at current paintings. Its praise or dispraise was a favoured debating-topic, because it lent itself to eloquence. An extraordinary number of opinions about painting were in the air, and a man could hold more than one of them. For example, in one work John Case disparages painting, in another piece of writing he praises it.[3] Stephen Bateman (d.1584) is an even stranger case-history. He worked for the Archbishop of Canterbury, Matthew Parker, who was a patron of painting, at least of limning.[4] He wrote what was virtually a handbook of iconography, *The Golden Booke of the Leaden Goddes* (1577), the first in English. In it he endorses a condemnation of painting:

A. What is a Picture?
E. A Glosing treuth.
A. Why doste thou tearme it so?
E. Because wee see Apples, flowers, lyvinge creatures, Golde, & Silver, & they are not the very true, & selfe same thinges.[5]

This did not prevent him publishing instructions on painting, in *Batman uppon Bartholome* (1582). He quoted Aristotle's approval of painting, and H.C. Agrippa's widely known account of the art. He also threw in marginal comments on the nature of English, French, German and Italian painting, as he saw them.[6] Such a diaspora of attitudes was possible because, as Graham Reynolds pointed out some years ago,[7] there was no single strongly-established school of painting in England in existence at the time; had there been one, men's views on painting would have had something on which to anchor. As it was, even the word itself was ambiguous, and the kinds of painting practised were not clearly classified or named. The net result of this state of affairs was that one attitude to art did not necessarily preclude another.

Conditions in England where the visual arts were concerned meant

[3]*Sphaera Civitatis* (Oxford, 1588), pp.714-15: Case rehearses arguments for and against the teaching of painting in schools (I am grateful to A. Moffat for this reference); in his letter prefacing Haydocke's *Tracte*, Case admits that hitherto he has never done justice to the art of painting. [4]See above, ch.II, note 57. [5]*The Golden Booke*, fols 24ᵛ-25ʳ. [6]*Batman uppon Bartholome*, pp.396-96. For his remarks on painters, see above, ch.II, note 12. [7]'The Elizabethan Image', *Apollo*, 91 (1970), 138-43, (p.142).

that a poet could all the more easily launch into a realm of painting which actually existed only in his head. This realm was one in which the *trompes l'œil* of Apelles hung side-by-side with perspective-pictures and landscapes, 'pictures in small' of Queen Elizabeth, or the poet's mistress. It constituted a realm of pictures both 'curious' (that is, artistic) and loyal, a microcosmos (as Whetstone described a picture-gallery)[8] of pictures so skilfully handled in respect of shadows, perspective and colours, that they seemed 'to live indeed'.

But how could painting have appeared so infinitely desirable to a writer that he felt well-advised to praise it, to paint pictures in words, to advance the claims of his own art under its wing, to make out a case for the claims of poetry to feign by comparing it to the feigning art of painting? The answer is that once safely within the bounds of theory, painting and the arts of picture could be very highly praised indeed. They worked through the sight, 'the nobler sense' that was associated with light, creativity and God. Sight was the sense of invention, according to Aristotle; it was the first step on the road to the apprehension of heavenly beauty. It was a source of faith, since by beholding the splendour of the created world, man must be led to assert his belief in the Creator and His bounty.[9]

Rhetoric too traditionally exalted sight by praising the visual image as a model of eloquence. Cicero and Quintilian urge the orator to appeal to the mental eye when describing a subject.[10] With English Renaissance rhetoric books, a change occurs; Quintilian's recipe for vividness — 'Keep your eye on Nature and follow her' — becomes in England: 'Keep your eye on the painter and follow his picture.' Sherry, for example, says in 1555 that in a subject well described 'the reader, semeth to see it before his eies, as though it wer livelye painted in a table'.[11] And the elder Peacham says *hypotiposis* is a kind of description so vivid 'that it seemeth rather paynted in tables, then expressed with wordes'; it is the painting of 'each thing in his due collour', just as 'the cunning Paynter paynteth all manner of thinges most lyvely, to the eyes of the beholder'.[12]

The visual image is, of course, more immediately eloquent and

[8]*An Heptameron*, sig. Mii^v. [9]Such views are widely spread in Elizabethan books. They are all to be found in A. Du Laurens, *A Discourse of the Preservation of the Sight*, translated by R. Surphlet (London, 1599), ch.3. St Augustine's 'But sight shall displace faith' (*De Doctrina Christiana*, I.38,42) is quoted by J.A. Mazzeo, *Renaissance and Seventeenth-Century Studies* (London, 1964), ch.1. The importance of the image in the Renaissance is argued by E.H. Gombrich, *Symbolic Images* (London, 1972), pp. 123-98 (amplified from '*Icones Symbolicae*: the Visual Image in Neo-Platonic Thought', *JWCI*, 11 (1948), 163-92), some of whose arguments are challenged by D.J. Gordon, *The Renaissance Imagination*, ch.1. [10]For example, Cicero, *De oratore*, III.40, 161-62, and III. 52-53; Quintilian, *De institutio oratoria*, VIII.3,71. [11]*A Treatise of the Figures of Grammar and Rhetorike* (London, 1555), fol.xlv^r. [12]*The Garden of Eloquence* (London, 1577), sig. Oii^r.

communicative than words dispersed in time; what is curious is why the rhetoricians chose to single out painting. There were various reasons for praising 'picture' in its wider meanings. For example, it was thought to have preceded language as a means of communication: 'Hieroglyphicall Figures on the AEgyptian Obelisques. . . were long before the invention of Letters.'[13] A shade nearer to painting are the 'pictures' of the memory. The memory was thought of as a storehouse of pictures[14] and, as it was the means to overcome 'bestial oblivion', in the individual's mind pictures were reckoned to be more durable than images created by words. For one of the most potent attributes of painting was its eternalising power. This can be invoked by a poet in praise of his own art, as Samuel Daniel does in sonnet 34 of *Delia*:

> When Winter snowes upon thy golden heares,
> And frost of age hath nipt thy flowers neere:
> When darke shall seeme thy day that never cleares,
> And all lyes withred that was held so deere.
> Then take this picture which I heere present thee,
> Limned with a Pensill not all unworthy:
> Heere see the giftes that God and nature lent thee;
> Heere read thy selfe, and what I suffred for thee.
> This may remaine thy lasting monument,
> Which happily posteritie may cherish:
> These collours with thy fading are not spent;
> These may remaine, when thou and I shall perish.
> If they remaine, then thou shalt live thereby;
> They will remaine, and so thou canst not dye.

Or it can be used to praise nature itself, as in a description of a paradise: '. . .variable flowers like a painting, remaining alwaies unhurt, with ther deawie freshnesse, reserving and holding their colours without interdict of time'.[15]

Painting as an art had been approved by Aristotle as an accomplishment that by respectable means brought its practitioners wealth and fame.[16] By the second half of the sixteenth century it had acquired a potent mythology, with Leonardo powerfully updating its claims to creativity, fame, immortality, and eloquence.[17] Though Leonardo

[13]George Sandys, 'To the Reader', *Ovid's Metamorphosis Englished*, 2nd edition (Oxford, 1632). [14]For example, *Hamlet*, I.5.98, 'the table of my memory'. The art of memory (Cicero, *De oratore*, II.87,358-60) associated pictures and memory, and its survival (in, for example, Thomas Wilson, *The Arte of Rhetorique* (London, 1553), fols 111ᵛ-16ᵛ) encouraged thinking of the memory in pictorial terms. See Frances Yates, *The Art of Memory* (London, 1966). [15]Daniel, *Poems and A Defence of Ryme*, edited by A.C. Sprague (Chicago and London, 1930), p.27: R.D., *The strife of Love in a Dreame*, fol.91ᵛ. [16]*Politics*, VIII.3, endlessly cited in the Renaissance. [17]*Paragone: a Comparison of the Arts*, edited by I.A. Richter (London, 1949), especially pp.49-77.

himself is hardly mentioned in Elizabethan England, echoes of his 'Paragone' seem to have reached England,[18] and when Lomazzo arrived, in Haydocke's translation, some of the key views of the 'Paragone' were available in English: painting is 'in my smal judgment . . . the most divine and excellent arte in the world, insomuch as it maketh the workeman seeme a Demi-god. And these are *Leon:* owne words upon which matter he is very copious.'[19]

This quotation gives the clue to much of the writer's admiration of the painter, since in the picture mythology the artist's status is notably exalted. While in actual practice in England a painter's name is rarely mentioned in inventories, and he is often referred to as no more than the workman, in this mythology he becomes semi-divine.

The up-grading of the artist followed to a considerable extent from the Neo-Platonic doctrine of Idea.[20] That is, the artist, instead of having to rest content with the shadows of superficial appearances, can, by means of his divine gift, reach behind to comprehend and express the essence, the Idea. The excellent artefact comes to be preferable to, or truer than, its natural counterpart, which is transmitted via material, and hence is always likely to be flawed, whereas the artist's work of art bypasses the material version of what he imitates. Lomazzo's *Trattato* is virtually a handbook of the doctrine, and long before Haydocke's translation appeared Sidney's *Apology* had assumed the truth of the theory. The artist chosen to illustrate it tends to be primarily the painter; it is his picture of Lucrece, rather than the poet's verbal portrait, that is first cited to demonstrate the artist's powers.

The typical note of the English praise of painting is well caught by the curious play, *The Wisdome of Dr Dodypoll* (printed 1600). It incidentally contains a character called 'Alberdure', a form of Albrecht Dürer's name also used by Peacham in 1606.[21] However, the painter of the play is Lassingberghe, 'All day a Painter, and an Earle at night', thereby showing — like Rubens — that gentility was compatible with the practice of painting, although Lassingberghe's morals are not above reproach, so his character confirms the old prejudice that painters are morally unreliable.[22] His painting, we are told, is

[18]A. Blunt, 'An Echo of the *Paragone* in Shakespeare', *JWI*, 2 (1939), 260-62. A paragone of poet and painter is also to be found in *Queen Elizabeth's Entertainment at Mitcham*, attritbuted to, but almost certainly not by, Lyly; edited by L. Hotson (New Haven, 1953). [19]Lomazzo/Haydocke, *Tracte*, 2,61. [20]See above, ch.II, note 19. [21]*Arte of Drawing*, p.6. [22]Malone Society Reprint, prepared by M.N. Matson (Oxford, 1965 for 1964), sig. C3^r-v. The question of painting's gentility is discussed by, among others, A. Moffat, 'Lomazzo's Treatises', ch.4; F.J. Levy, 'Henry Peacham and the Art of Drawing'. The massive prejudice of the English can be found surviving nearly into the twentieth century: 'The pencil — the brush? They're not the weapons of a gentleman', says Mr Carteret in Henry James's *The Tragic Muse* (1890), ch.23.

of a high order. When he disguises himself as a journeyman painter, Cornelius, to pursue his amours, the deception is exposed because a connoisseur, looking at a painting by 'Cornelius', sees that 'More Art is shaddowed heere' than any German except Lassingberghe can display. His is an 'eye-ravishing Art'. 'That faire artificiall hand of yours', says his sitter to him, 'Were fitter to have painted heavens faire storie / Than here to worke on Antickes and on me'. To which Lassingberghe replies with a fine panegyric:

> Why the world
> With all her beautie was by painting made. . .
> Looke on the sommer fields adorn'd with flowers,
> How much is natures painting honour'd there. . ?
> And to conclude, Nature her selfe divine,
> In all things she hath made, is a meere Painter.[23]

Here the idea of God as an artist comes close to the notion of God as a painter, hinted at, too, in a very different kind of writing, Du Bartas's *Les Sepmaines*, where he compares the newly created world to a marvellous landscape-painting.[24]

The English poet, then, had practically every reason to think of painting as an art of excellence. In fact, whereas Leonardo was stung into arguing its superiority because of the long-standing fashion for contending that poetry took first place, in England by the 1590s it is the poets who are paying homage to the sister-art of painting. It was in their own interests to do so. Painting presented them with a model which they could first imitate, thereby showing their eloquence, and then overgo. Painting, above all, feigned.

Its feigning was not a matter of theory but of fact. Even crude paintings offered images which were not the 'very true & selfe same things' as the objects they imitated.[25] Painting skilfully done offered tangible and lifelike images of actual objects. By means of perspective and chiaroscuro it could produce on a two-dimensional surface the impression of a three-dimensional landscape, say. Norgate develops the fifteenth-century Italian definition to stress the illusion; for, he says, 'the end of all drawing [is] nothing else but soe to deceave the Eyes, by the deceiptfull jugling and witchcraft of lights and shadows,

[23]Sig. A3[r-v]. [24]'The Seaventh Day of the First Weeke', in *The Divine Weekes and Works*, edited by Snyder, I, 294-96. The topos is discussed by E.R. Curtius, *European Literature and the Latin Middle Ages*, translated by W.R. Trask (London, 1953), Excursus XXI. The elder Philostratus, *Life of Apollonius of Tyana*, II.22 (Loeb edition, I, 175) describes God as a painter. Elizabethans would not have known of Dosso Dossi's painting of Jove painting butterflies, but the picture and its literary sources are evidence of the Renaissance interest in the idea of God the painter; see J. van Schlosser, 'Der Weltmaler Zeus: ein Capriccio des Dosso Dossi', in *Präludium* (Berlin, 1927), pp.296-303. [25]Bateman, *The Golden Booke*, fol.25[r].

that round embost and sollid Bodyes in Nature may seeme round embost and sollid in *Plano*.'[26] How deceitful the image, yet how delightful the deception. Painting could yet again produce lifelike images of impossible things, such as chimeras, hydras or griffons, making them look plausible. The special agents were shadowing and perspective: devices which, to quote Hilliard once more, enabled the painter by falsehood to achieve truth.

Such stress on falsehood gave a new meaning to the old definition of painting offered by Isidore of Seville, a definition brought forward in print again by Stephen Bateman in one of his additions to Trevisa's translation of Bartholomaeus Anglicus' *De Proprietatibus Rerum* (1582): 'A Picture is called *Pictura*, as it were *Fictura*, feyning.'[27] Thus, revived by men's experience, the argument developed in antiquity came alive for the English: the more a picture feigned, the more excellent a painting it was. 'A painting is true in the measure to which it is false; the more a portrait gives us the illusion of a real man and, consequently, the more it tricks us, the more it is a true work of art.'[28] A good picture, says Burton, 'is a *falsa veritas*'.[29] The fictional element in painting was therefore what gave it its proper and indestructible value, and so also what gave it a certain proper autonomy. Its order is one 'other than morality'; a painting is only an image which the cultivated man perceives as such, that is as a representation or an illusion of reality. So in itself the work of art belongs neither to the religious category, nor to the moral category, nor to that of physical reality; it belongs to a special category, that of art.'[30] When one remembers the energies devoted to denouncing image-making as false counterfeiting in the second half of the sixteenth century, a shift which made a counterfeit true in the measure to which it was false was a remarkable revolution.

Ironically, antiquity had argued the case at least as strongly for literature. For example, Plutarch had quoted Gorgias who 'was wont to say of a Tragedie, That it was a kinde of deceit, whereby he that

[26]*Miniatura*, p.80. Norgate is following Hilliard ('The Arte of Limning', p.20). [27]*Batman uppon Bartholome*, p.396. Compare *Etymologiarum sive originum*, edited by W.M. Lindsay, 2 vols (Oxford, 1911), II, Book XIX. 16. [28]E. De Bruyne, *L'esthétique du moyen âge* (Louvain, 1947), p.54. That De Bruyne says this in the context of the *Libri Carolini* does not lessen its pertinence for England c.1600, since the *Libri Carolini* are arguing for the validity of pictorial art in the wake of iconoclasm, just as English poets are wishing to establish literature as art in the face of iconoclasm's antagonism to art; and the classical sources — Plutarch, and Pliny — are the same in both cases. [29]But not until the second edition of *The Anatomy of Melancholy* (Oxford, 1624), p.233; Part 2, sect.2, memb.4. This section is considerably expanded between the first and the fourth editions. Francis Junius says in *The Painting of the Ancients* (London, 1638), p.54: it is 'generally knowne that a good Picture is nothing else in it selfe but a delusion of our eyes'. Predictably, he has just quoted Plutarch 'On how to read poetry'. [30]De Bruyne, *Études d'esthétique médiévale*, I, 272-73. Such an argument was radically different from an *utile et dulce* justification, which left art in the moralist's domain.

deceived became more just than he who deceived not; and he that was deceived, wiser than another who was not deceived'.[31] But English literature in the 1580s had neither the moral standing nor the aesthetic freedom to present this case for itself in such a direct way (least of all literature of the theatre). What happened was that poets side-stepped the moral objections of their critics by masquerading under the artistic credentials of painting, finding an identity in which moral worth and aesthetic freedom were simultaneously established by an ability to produce a marvellously lifelike illusion. Needless to say, poets go on to repudiate the art of painting, their performances tacitly, if not overtly, proclaiming how much better poets can do it.

One model of the mechanism by which painting could be made to assist poetry can be seen at work in Sidney's *Apology*, at the centre of whose campaign to prove poetry's right to feign lies a theory of feigning images.[32] One of his aims is to show that if poetry's function is to delight and instruct, then 'a feigned example hath as much force to teach as a true example'. His other aim is to prove poetry more excellent than other 'sciences', to prove 'our poet the monarch'. He establishes both points eloquently; his way to them is via the visual artefact. He first states that the 'right describing note to know a poet by [is] that feigning notable images of virtues, vices, or what else, with. . . delightful teaching'. 'Images' in this context means, as usual, pictures or works of art in some way visual;[33] 'feigning images' therefore means making imaginary pictures whose excellence depends on the fact that they *are* imaginary (since *pictura* is as much as to say *fictura*).

He then invokes the 'well-painted' image which gives the spectator a quicker and deeper understanding than the actual object ever could. This enables him in his argument to arrive at the 'speaking picture of poesy' which can illuminate 'many infallible grounds of wisdom' for the reader. Having reached this position he then goes on to justify verbal images feigned by the poet, by which time the well-painted picture has disappeared from sight; but it was a necessary stage in the argument to advance the excellence and superiority of poetry.

By the 1590s one discovers a remarkably keen consciousness that, to adapt Touchstone's wit, the truest art is the most feigning: the essence of art lies in the artist's success in lifelike imitation, that is to say, in deception. Francis Meres in *Palladis Tamia* (1598), for instance, not once but three times within a short space reminds his reader that successful images of unpleasing subject-matter can produce great pleasure in the spectator:

[31]*Moralia*, translated by Philemon Holland (London, 1603): 'How a yoong man ought to heare Poets: and how he may take profit by reading Poëms', p.19. [32]*Apology*, edited by Shepherd, pp.103-13. [33]To confirm this equation, see T. Wilson, *The Arte of Rhetorique*, fol.114[v] (based ultimately on Vitruvius' definition of painting): 'An Image what it is./An Image is any picture or shape, to declare some certayne thing therby.'

> As we are delighted in deformed creatures artificiallye painted: so in poetrie, which is a lively adumbration of things, evil matters ingeniously contrived do delight.[34]

Granted the thought is no novelty — Sidney had naturalised it for English poetry in 'Oft cruel fights well pictured forth do please'[35] — granted also Meres acknowledges that he is following Plutarch's 'On how to read poetry'; nonetheless, only towards 1600 do the English seem to realise its implications for the status of art. Philemon Holland's translation of Plutarch's essay followed in 1603, where antiquity's strongest case for the *falsa veritas* justification of art is set out. The student of poetry, says Plutarch, must not only

> be acquainted with the hearing of that vulgar speech so common in every mans mouth, that Poësie is a speaking picture, and picture a dumbe Poësie: but also we ought to teach him, that when we behold a Lizard or an Ape wel painted, or the face of *Thersites* lively drawne, we take pleasure therein & praise the same wonderfully; not for any beautie in the one or in the other, but because they are so naturally counterfeited.[36]

The lie it is that pleases, whether it is the painter's capacity for mendaciously lifelike images, or the fable embellishing the poem, or the actor's art, or, in the poet's style, a high degree of figurative language; for the innate doubleness of man's mind is such that he responds to these forms of duplicity while he is left unmoved by the 'simple and uniforme'.

It is no surprise, therefore, that English poets, eager to assert themselves as the peers of Continental artists, makers and creators such as Sidney described, imitated the fictive stand of painting in a variety of ways, whether they were writing sonnets, epic, or Ovidian narratives such as *Venus and Adonis. The Faerie Queene* is the embodiment of the theory put forward by Sidney. Spenser uses the speaking picture of poesy to create feigned images of virtues, vices and so on, which give pleasure and at the same time, because they illuminate the 'imaginative and judging power', are more profitable than the prosaic and even historically true examples of philosophy and history.[37] He also constructs the whole poem, as many critics have pointed out, around contrasts of light and shade so that it is like a vast well-shadowed picture, for the contrasts attach to truly pictorial effects (like Una laying aside her stole).[38] They are not only or purely metaphorical contrasts between good (light) and evil (dark); and anyway evil may be — as Spenser often insists, for example in Lucifera

[34]*Elizabethan Critical Essays*, II, 309; also pp.311-12. [35]*Astrophel and Stella*, sonnet 34; based on Aristotle, *Poetics* 1448[b], and also used by Sidney in the *Apology*, p.114. [36]*Moralia*, p.22. [37]Sidney, *Apology*, p.107. [38]*Faerie Queene*, I.3.4.

and her entourage[39] — as apparently light and shining as the purest virtue. Spenser's pictorial effects increase enormously the life and appeal of the poem, offering the reader a freedom of vision (and the necessity for choice) which would be denied him if the poet's visual language was only that of the emblem. It is rather ironic that Spenser, whose main subject is arguably the error of illusion, or delusion, should nonetheless display an art which depends considerably on illusion, though doubtless *The Faerie Queene* would be a closed book today if he had not done so.

Even more striking are the pictorial affinities of the art-loving Ovidian narratives. Here the poet flaunts his fictions and illusionist devices, as it were asserting that he is like the skilled painter who deceives in order to depict the truth. The author of such a poem chose, like Spenser for *The Faerie Queene*, fictional subject-matter. He asserted his poem's world through virtuoso descriptions of virtuoso artefacts; such are the skilful piece of painted work in *Lucrece*, and Chapman's account of the anamorphosing statue of Niobe at the opening of *Ovids Banquet of Sence*, a statue,

> So cunningly to optick reason wrought,
> That a farre of, it shewd a womans face,
> Heavie, and weeping; but more neerely viewed,
> Nor weeping, heavy, nor a woman shewed.[40]

In a different genre of poem, *Mortimeriados*, Drayton achieves a similar effect by his description of the painted chamber.[41] Marlowe's Hero, though she is human, is presented like a masque statue come to life, with buskins to excel even those that Inigo Jones's workmen would be able to achieve:

> Buskins of shels all silvered used she,
> And brancht with blushing corall to the knee;
> Where sparrowes pearcht, of hollow pearle and gold,
> Such as the world would woonder to behold:
> Those with sweet water oft her handmaid fils,
> Which as shee went would cherupe through the bils.[42]

The wizardry of the picture makes us overlook the disagreeable fact that her kirtle shows 'many a staine,/Made with the blood of wretched Lovers slaine'. Marlowe is like the painter whose skill in imitation causes the spectator to be fascinated by the feature that in actual life would be ugly or unpleasant. The figure of Hero makes the poem from

[39]*Faerie Queene*, I.4. [40]*Lucrece*, ll.1366-533. *Ovids Banquet of Sence*, stanzas 2-6.
[41]*Works*, I.357-77, ll.2311-94. Compare the version in *The Barons Warres*, in *Works*, II,110-14, Canto VI, ll.233-344. [42]*Sestiad* I. 31-36.

the start seem more than purely lifelike; it has a verisimilitude taken
from the poet's imagination of life's capacities, not simply copied from
life.

Nor is Marlowe the only writer to incorporate the super-lifelike
quality of the amazing work of art into his own poem. Shakespeare
uses the same strategy in his portrait of the horse in *Venus and Adonis:*

> Look, when a painter would surpass the life
> In limning out a well-proportioned steed,
> His art with nature's workmanship at strife,
> As if the dead the living should exceed;
> So did this horse excel a common one
> In shape, in courage, colour, pace and bone.[43]

Shakespeare after this fanfare of course presents us with his own
version of a horse, which has a life and movement such as the painter
cannot rival.

A poet could also make images which, like perspective-pictures,
need to be looked at from the correct angle for the lifelike proportions
of the image, and its exact meaning, to appear. This was certainly a
ploy of Chapman's, whose narrative poem, *Ovids Banquet of Sence,* is
still today an undeciphered perspective-picture for the reader, who has
to find the right way of looking at it to make sense;[44] and even *Venus and
Adonis* offers us so many angles to view it from that we walk around it
wondering just which one to choose. Is the picture of Venus that of a
beautiful woman, or is she really like that overblown lady, the Duchess
of Suffolk, standing next to her young prize, her master of the horse, in
Eworth's painting?

The suggestion that poetic style owes a debt to the good picture's
brand of falsehood is at first glance implausible, since what has style to
do with illusionistic pictures? However, Sir Henry Wotton certainly
saw pictorial art as analogous to rhetorical art, arguing that just as in
the art of persuasion the art is concealed, so in the transition in a
picture from light to darkness, 'the *Sight* must be sweetly deceaved, by
an insensible passage, from *brighter* colours, to *dimmer*'.[45] And such a
view was not without an ancestry. As has already been hinted, Plutarch
asserts that the poet's figurative language, the 'ornaments & beautifull
furniture of figurative speeches', is another form of fiction:

> But the Art of Poetrie setting aside the truth in deede, useth most of all
> varietie and sundry formes of phrases. For, the divers imitations are they,
> that give to fables that vertue to moove affection & passions in the readers:
> these are they, that worke strange events in them, even contrarie to their

[43]ll.289-94. [44]The state of critical play on this poem, and the varying inter-
pretations, are summed up by Louise Vinge, 'Chapman's *Ovids Banquet of Sence:* Its
Sources and Theme', *JWCI*, 38 (1975), 234-57. [45]*Elements*, p.87 (misnumbered 86).

opinion and expectation: upon which ensueth the greatest woonder, and astonishment, wherein lieth the chiefe grace, and from whence proceedeth the most delight and pleasure, whereas, contrariwise, that which is simple and uniforme, is not patheticall nor hath in it any fiction.[46]

Now tropes and figures of speech were widely recognised to be, in one sense, a breaking of the rules:

> As figures be the instruments of ornament in every language, so be they also in a sorte abuses or rather trespasses in speach, because they passe the ordinary limits of common utterance, and be occupied of purpose to deceive the eare and also the minde, drawing it from plainnesse and simplicitie to a certaine doublenesse, whereby our talke is the more guilefull & abusing.[47]

Puttenham is aware that, much as he favours richly figured and ornamented poetic language, to one school of thought such figured language offers 'meere illusions to the minde'. To Fulke Greville, for example, the shadows of art in words as well as in pictures are a regrettable deception. But it is precisely the 'meere illusions' that attract and engage the mind, and enable poetry to function in the distinctively fictive mode that proclaims its truth to reside in its falsehood. 'I am not I, pitie the tale of me': Astrophel knows that fiction has more power to move than the literal truth.[48]

So, although it would be ridiculous to suggest that writers of the 1590s chose to cultivate a highly figurative style simply because it corresponded to the skilful painter's use of devices working by illusion, the evidence suggests that illusionistic painting distilled the argument for art as *falsa veritas* in a way that no other model could have done at the time. At all events, a new-found taste for a certain sort of illusion in pictorial art is accompanied in England by verbal styles, especially Shakespeare's, that opt for metaphor, the old name for which, 'transmutacioun', stressed that it was a fictive, feigning figure.[49]

Chapman, for one, was prepared to argue that the true style of poetry lay in its handling of shadows and perspective:

> that, *Enargia,* or cleerenes of representation, requird in absolute Poems is not the perspicuous delivery of a lowe invention; but high, and harty invention exprest in most significant, and unaffected phrase; it serves not a skilfull Painters turne, to draw the figure of a face onely to make knowne

[46]*Moralia,* translated by Holland, p.33. [47]Puttenham, *The Arte of English Poesie*, p.154. Compare Hoby's translation of *The Book of the Courtier*, p.59. Castiglione's and Puttenham's source is Quintilian, *De institutio oratio*, II.13,10-11. Since writing this I have noticed that Ernest Gilman quotes the same passage from Puttenham, also apropos of literary and visual deceit, in *The Curious Perspective*, ch.3, 'Tesauro on Visual and Verbal Wit'. He does so in the course of developing the argument that tricks of perspective are closely akin to certain sorts of seventeenth-century wit in English poetry. [48]*Astrophel and Stella*, sonnet 45. [49]T. Wilson, *Arte of Rhetorique*, fol.93[r].

who it represents; but hee must lymn, give luster, shaddow, and heightening; which though ignorants will esteeme spic'd, and too curious, yet such as have the judiciall perspective, will see it hath, motion, spirit, and life.[50]

Illusion, effected by artistry, is intrinsic to both the image and its truth in such a work of art.

The case for the influence of painting on style must not be overstated. If illusion is the characteristic in point, then an obvious objection is that the theatre was a more powerful and influential model than the picture. But I do not think that theatrical illusion in the first place established the licence of poetry to feign, however much and however far theatre subsequently stimulated the range of dramatic poetry. For one thing, contemporary theory does not put forward theatrical illusion as a model for poetry, nor would it be likely to when theatre had even less justification in sixteenth-century literary apologetics than poetry. For another, there was no bridge between poetry and theatre of the kind so conveniently provided by the picture-poetry commonplace which allowed arguments for the one art to be transferred to the other. Perhaps it is germane to point out that Shakespeare's most memorable metaphors of theatrical illusion come after 1600; and, indeed, that the most memorable one of all, that of the 'insubstantial pageant faded', is based as much on the visual artefact of the masque as on theatre.[51]

Another factor to be taken into account is the theory of the ideal courtier. Recently, Daniel Javitch has argued that the delightful, deceiving figures of one kind of English Renaissance poetry developed as a result of Castiglione's concept of the courtier, in whom subtle deceits are acceptable because by their means he can achieve the virtuous end of influencing his prince towards good government.[52] The licence for deceitful figures given by the courtier ideal was undoubtedly important to writers; Javitch shows convincingly how closely Puttenham adapts Castiglione to produce a theory of poetic style. But plainly this kind of writing developed as the result of many impulses, including the model of the courtier's *beau semblant*, the stimulus of theatrical illusion, and the example of the excellent picture. Some of the time at least, highly figured writing is felt to correspond to pictorial models, and a great many writers cite the example of painting to justify their poetic procedures.

Insofar as they exploited the *ut pictura poesis* relationship to advance their art, they deployed the equivalent of shadows in their writing, trading on verbal effects which maximised illusion. They thus

[50]Preface to *Ovids Banquet of Sence*, in *Poems*, edited by Bartlett, p.49. [51]*The Tempest*, IV.1.148-58. [52]*Poetry and Courtliness in Renaissance England* (Princeton, 1978); ch.3 contains a discussion of Puttenham's views on rhetoric and duplicity.

used their art to get as much reality and life as possible into their poetry, at the same time as they knew that such shadowing was the *summa* of illusion. Their shadowing effects asserted, like those of Renaissance and Mannerist painting, that poetry's excellence lay in its power to deceive; that is, in an aesthetic dimension, and thus outside the domain of the moralists who wished to deny poetry's right to feign.

The word 'shadow' is so important in this context, where it acquires some radically new connotations, that it calls for further comment. Its adverse meanings earlier in the sixteenth century were far stronger than I have hitherto hinted, chiefly because of the long-standing pairing of shadow and substance, which down-graded shadow as the letter rather than the spirit, the illusion rather than the reality. Anything connected with 'shadow' was likely to be stamped worthless or suspect. A man's shadow was obviously insubstantial. A ghost, by definition suspect as well as lacking substance, could be called a shade. Actors, 'shadows', pretended to be what they were not.

The spokesmen against shadows were forceful and confident. Ascham, for example, presenting a friend with a book, says 'I give you suche ornamentes as are true in deede and not counterfecte: loe, these beautifull shapes, and amiable favours, are of this right kinde and propertie, that they blinde not the minde at any time with painted pretences, shewes, shadowes, and foolish allurements.'[53] Geoffrey Whitney, in the preface to his book of emblems (1586), says in their praise: 'Under pleasaunte devises are profitable moralles, and no shaddowes, void of substance.' Though the adverse meanings of 'shadow' persist, painting brings about a sharp change in some of the fortunes of the word, whereby 'shadow' can become the means to achieve substance, the illusion becomes the reality. A much-anthologised poem of the 1630s and 1640s begins 'If shadows be a painting's excellence';[54] already by 1600 poets were in effect saying that shadows were a poem's excellence.

The new associations of 'shadow' frequently opened the way for word-play. Haydocke, for example, introduces his translation of Lomazzo as 'this shaddow of my *Shaddowing Muse*'.[55] That is, as a translation it is merely a shadow of the original, and considered metaphorically as a picture, it is merely the preliminary draft. Nonetheless, he implies, it may prove to be the well-shaded, lifelike image, and true portrait, of *pictura*. Barnabe Barnes, in a madrigal and a sonnet of *Parthenophil and Parthenophe* (1593), develops amazing confusions through play on the word. In madrigall 4, the painter Zeuxis shadows the poet's mistress as she sleeps in her arbour, where roses and honeysuckle cast a shadow on her face, which shadow,

[53]Quoted in A. Fleming, *A Panoplie of Epistles* (London, 1576), p.442. [54]M. Crum, *First-line Index of English Poetry 1500-1800*, 2 vols (Oxford, 1969), I, 432. [55]*Tracte*, sig. ¶ ii^v.

He left unshadow'd, there art lost his grace.

So far, as good. But he continues, in the sonnet:

> Then him controulling, that he left undonne
> Her eyes bright circle thus did answre make,
> Restes mist with silver cloude had clos'd her Sunne,
> Nor could he draw them till she weare awake
> Why then quoth I were not these leaves darke shade
> Upon her cheekes depainted, as you see them:
> Shape of a shadow can not well be made
> Was answer'd, for shades shadowes none can eye them.

I do not understand exactly what Barnes means, nor apparently does his recent editor.[56] I would like to think that Barnes was referring, among other things, to a tradition in English painting which eschewed shadows; Hilliard, for example, in 'A Young Man Among Roses', does not appear to have painted the shadow cast by the rose branches on the young man's body and face. Then one would have an example of English verse actually referring to a real picture, or real type of picture. The ambiguities unfortunately reduce such an interpretation to the status of tentative hypothesis. The sonnet, however, has moved a long way from its purely literary, Anacreontic model. 'Shadows' are obviously real in Barnes's experience of pictures, as a sign of the painter's artistry and a painting's excellence, even if the painter ends up defeated by the task of portraying the poet's mistress's beauty; such, after all, is a conclusion which works to the poet's advantage, since he can, presumably, do the job better.

Barnes cannot really enrich his meanings by his word-play around paintings. Shakespeare's *Sonnets* are another matter. One of the developments in them, illustrated for example in sonnets 43 and 53, is that the poet inverts the usual relation of shadow and substance, giving to the friend all the virtues of substance, thus making everything else in the world seem illusory, nature herself a bankrupt:

> Speak of the spring and foison of the year:
> The one doth shadow of your beauty show,
> The other as your bounty doth appear.[57]

This inversion of values prepares the way for the devastation that occurs when the poet is forced to admit the friend's corruption (around sonnets 95, 96 and 97). Shakespeare's claim that the friend is the source of value does not come across as pure hyperbole; one takes it as

[56]Sonnet 14; edited by Doyno, p.12. [57]These lines and the next to be quoted are taken from sonnet 53.

actually experienced and as in some way true. He is able to claim psychological plausibility for his daring change in the positions of shadow and substance, partly by an appeal to his reader's own experience that the illusionist painting can indeed feel more real than the actual life outside its frame:

> What is your substance, whereof are you made,
> That millions of strange shadows on you tend?

The shadows may be court-flatterers, or they may be the shadows of an excellent portrait.[58] But since the poet seems to be addressing the actual friend, rather than his picture, what relevance has the idea of a portrait? The effect of Shakespeare's lines is to make us feel that the life of the friend exceeds in its degree of reality the life of those around him, in the same way that a superb portrait makes life outside it pale into lesser significance. The friend is, if you like, nature's most excellent work of art; put another way, what we see in the friend is life itself o'er-picturing that image where we see the fancy outwork nature.[59] Thus, it is through an appeal to the feelings that can be conjured up by seeing a lifelike painting that Shakespeare makes real his praise of the friend.

Of course, pictorial shadows are only one kind of shadow in a period that, while preoccupied in general with the problem of appearance and reality, is interested in all forms of the shadow-substance pairing: dream, actor, ghost, mirror-image as well as pictures. The very word 'shadow' permeates some satire, such as John Marston's *Certain satyres* (1598), and Edward Guilpin's *Skialetheia*, subtitled *A shadowe of truth* (1598). Since satire often arises from looking at your subject from an unexpected angle, the question of an image's real or apparent truth is bound to recur. Shadows infiltrate more serious literature, too, such as those passages of the deposition scene in *Richard II* where Richard, prompted by Bolingbroke, ponders the relation between the sun he has imagined himself to be and the shadow of himself which he finds he is reduced to.[60] In yet another genre, Fulke Greville throughout *Caelica* often reminds the reader of the various kinds of shadows with which man involves his life.

Perhaps one can go a little beyond merely remarking the phenomenon. Speaking of fictions, in narrative and drama, several critics have recently remarked that some kind of crisis over deception, and the moral attitude to be taken to it, occurs towards 1600.[61] The

[58]This point is made by Douglas Chambers, '"A speaking picture"', p.32. [59]*Antony and Cleopatra*, II.2.208-29. [60]IV.1.276-302. Shadows and perspective in *Richard II* have been explored by Ernest Gilman in *The Curious Perspective*, ch.4, to which he adds further remarks in 'Shakespeare's Visual Language', *Gazette des Beaux-Arts*, VIe période, tome 96 (July-August 1980), 45-48. [61]See L. Salingar, *Shakespeare and the*

accuracy of the diagnosis is confirmed by Englishmen's fascination
with the feigning nature of Renaissance and Mannerist painting, and
the *falsa veritas* of pictorial illusion enables us to define the crisis more
closely. For the point is that up to around the 1580s men could
idealistically believe that the substance of the truth might be
perceived, *if only* man would renounce his tendency to be attracted by
painted pretences, shows, shadows and foolish allurements. Towards
the turn of the century, however, they become aware that the very
means to perceive the truth has a physical, as well as a moral,
dimension which dictates that it shall be inseparable from falsehood.
The eye has to accept deceptions to record accurately what it sees, just
as the writer can only depict an unfallen, purely natural world by
recourse to 'nice Art'.[62]

Whereas Milton, in the middle of the seventeenth century, might
have thought 'no truth without illusion', writers around 1600 might
have been bold enough to say 'no illusion without truth', for they used
daringly the idea of their power over illusion to advance their art. A
word more needs to be said about the way in which they did so. What
they repeatedly praise in the 1590s and early 1600s is lifelikeness; and
not simply verisimilitude, the bare imitation of nature, but lifelikeness
achieved by artistic skill, which leads to extreme consciousness of the
art. Ben Jonson summed it up thus:

> In Picture, they which truly understand,
> Require (besides the likeness of the thing)
> Light, Posture, Height'ning, Shadow, Culloring.[63]

Such is the skill evoked in *The Taming of the Shrew:*

> Dost thou love pictures? we will fetch thee straight
> Adonis painted by a running brook,
> And Cytherea all in sedges hid,
> Which seem to move and wanton with her breath
> Even as the waving sedges play wi'th'wind.
> – We'll show thee Io as she was a maid
> And how she was beguiled and surpris'd
> As lively painted as the deed was done.
> – Or Daphne roaming through a thorny wood,
> Scratching her legs, that one shall swear she bleeds;

Traditions of Comedy (Cambridge, 1974); Philip Edwards, 'Shakespeare and the Healing
Power of Deceit', *Shakespeare Survey*, 31 (1978), 115-25. [62]*Paradise Lost*, IV.241. A.
Bartlett Giamatti, *The Earthly Paradise and the Renaissance Epic* (Princeton, 1966),
pp.295-360, argues that Milton's Eden is a 'setting for illusion', and that 'as he is
describing the perfect place, Milton is also. . . preparing us for the Fall' (p.302).
Giamatti elsewhere discusses deception in Spenser; *Play of Double Senses: Spenser's
'Faerie Queene'* (Englewood Cliffs, N.J., 1975). [63]Commendatory lines to T. Wright's
Passions of the minde (London, 1604); *Works*, VIII, 370.

> And at that sight shall sad Apollo weep,
> So workmanly the blood and tears are drawn.[64]

Praise of this kind involves two overlapping and interlocking formulae. One is 'so lifelike that the picture seems to live', the other 'so lifelike that I was deceived into thinking the image was alive'. Poets use the first to express their ambition to create a living art. 'Living' is ambiguous of course; it may mean continuing to live in men's memories:

> So long as men can breathe or eyes can see,
> So long lives this, and this gives life to thee.[65]

Or it can mean 'drawing breath'. The first meaning is innocuous; painting does indeed bestow fame — we remember Apelles, and we remember his portraits of Alexander. The second meaning is much more daring. Lyly, in the 1580s, specifically excludes it: 'tushe there is no paynting can make a pycture sensible'.[66] Or again:

> *Parrhasius* painting *Hopplitides* could neither make him that ranne to sweate, nor the other that put off his armour to breathe, adding this as it were for a note, *No further than colours:* meaning that to give lyfe was not in his Pencill but in the Gods.[67]

The classical source does not offer a 'note' spelling out the limitations of painting; it is Lyly himself, interested in art rather than illusion, who feels it important to exclude any Promethean ambitions of the artist. And this is understandable in a climate of iconoclasm, in which one of the arguments against images was that ignorant or foolish spectators might actually believe them to be inhabited by a spirit.[68]

What is surprising is the daring with which poets of the 1590s toy with the idea of living, breathing images, asserting that great artists had a power to instil a supernatural degree of life into their artefacts. This 'Pygmalion-complex', as Joan Grundy has called it, is marked in the sonnet sequences, and particularly in Shakespeare's.[69] He repeatedly wills his poems to continue not simply as static images, as Daniel was content to eternalise Delia, but as poems living with the very essence of the friend's life. Shakespeare is partly enabled to do

[64]*Induction*.2.47-59. [65]Sonnet 18. [66]*Works*, II, 89. [67]*Works*, II, 114. [68]A staple accusation against images; a late citing of it occurs in J. Mede, *The Apostasy of the Latter Times. . . or, the Gentiles Theology of Daemons* (London, 1641), p.20, quoting Hermes Trismegistus: 'Therefore they devised an art to make Gods, (he meaneth Images) and because they could not make soules, (he meanes to these senselesse bodies) therefore they called the soules of Dæmons, and Angels, and put them into their Images, and holy mysteries; by which meanes alone these Images have power of helping, and hurting.' [69]'Shakespeare's Sonnets and the Elizabethan Sonneteers', *Shakespeare Survey*, 15

this by the Horatian tradition: 'I have finished a monument more lasting than bronze and loftier than the Pyramids' royal pile.'[70] But the classical precedent does not allow him to talk about his portraits as living in the sense of breathing. It was the model of the truly lifelike visual image, so lifelike that it seems to live indeed, which enabled him to do that.

The ambition to make a transformation from art to life is not confined to the sonnet sequences. Chapman is a particularly strong spokesman of 'Promethean poets' who, 'with the coles/Of their most geniale, more-then-humane soules/In living verse', can bring characters to life. He sums up one poetical ethos of the 1590s when he writes that poetry's 'Promethean facultie/Can create men, and make even death to live'.[71] A genre which Chapman wrote in, the Ovidian narrative, where, as in sonnet-writing, the poet is making large claims for himself as an artist, frequently, indeed typically, creates vivid visual artefacts which seem to come alive. The astonishing quality of life in Marlowe's *Hero and Leander* remains one of the poem's most enduring qualities, as well as being the characteristic that led many contemporaries to imitate the poem. The *tour de force* begins with the very pictorial and masque-like figure of Hero, a work of art, described in outrageously hyperbolical and artificial terms, that comes to life, moves and has an existence in time. Marlowe makes her a breathing image; more than that, her breath is so sweet that

> there for honie bees have sought in vaine,
> And beat from thence, have lighted there againe.[72]

One of the many poetasters who imitated the poem, Thomas Edwards, laments the limitations of his own 'slow Muse' specifically in terms of the living artefact:

> So I cannot cunninglie
> Make an image to awake.[73]

And John Marston, in the late 1590s, actually took the story of Pygmalion for his Ovidian narrative, offering a lubricious version of the story that in some ways reads like a parody of the genre. He seems to have been irritated by the claims of some of his fellow poets, for not only does *The Metamorphosis of Pigmalions Image* satirise the type of narrative on which it is based, but it was published with other satires in a volume which Marston cynically consigned, not to fame, but to

(1962), 41-49. [70]*Odes*, III.30; also Ovid, *Amores*, I.15. [71]*The Shadow of Night*, in *Poems*, p.22, ll.131-33; 'Poems. . . to the Iliads and Odysseys', p.388, ll.137-38. [72]*Hero and Leander*, ll.23-24. [73]*L'Envoy to Narcissus*, edited by W.E. Buckley, Roxburghe Club (London, 1882), p.61.

oblivion.[74]

Stories of amazing artefacts coming to life disappear from poetic fiction around 1600 to reappear in court-masque in, for example, silver or golden statues that during the course of the masque come alive, descend from their niches.[75] And certainly the masque, particularly as developed by Inigo Jones, is the extreme example of the picture with perspective that has to be looked at from the right angle; the reactions of spectators who, seeing the spectacle, do not interpret it correctly, are amply documented.[76] Inigo Jones even goes so far as to describe the masque as 'nothing else but pictures with Light and Motion', as though it was, for him, the visual artefact that is so lifelike that its figures speak, move and dance.[77] Masque takes to an extreme the artist's enormous power to create and entrance, a power which, I have argued, is established in England via the model of the painter and his picture (or the sculptor and his statue).

The second 'so lifelike' formula — 'so lifelike that I was taken in' — like the first, offers the artist ample scope to expatiate eloquently on the qualities in the work of art that prove so delightfully deceptive. It specially stresses the role of the spectator in giving the work of art an existence, and thus works as a model that is very amenable to the writer's interests, for what life has the book or the poem until its black and white picture is brought out of anonymity by the reader?[78] The part the viewer plays in front of a visual artefact can be a naive one: 'Yea a man might have beene indifferently wise enough, in other ordinarie matter, and yet have adventured to have gathered a Flower, or have plucked an Apple',[79] though as Pliny himself had recounted

[74]*The Poems of John Marston*, edited by A. Davenport (Liverpool, 1961), p.175. [75]For example, Thomas Campion, 'Lord's Masque' (1613), in *The Works of Thomas Campion*, edited by W.R. Davis (London, 1969), pp.255-58. [76]Discussed by S. Orgel and R. Strong, *Inigo Jones: the Theatre of the Stuart Court*, 2 vols (London, 1973), I, 7-14, 23. The authors' discussion of perspective, illusion, and wonder in Jones's masques is highly germane. [77]Aurelian Townshend, *Tempe Restord* (London, 1631), p.3; Orgel and Strong, II, 480. [78]There is ample evidence that the Elizabethans were prepared to see writing, or print, as a picture in black and white. See Sidney, *Astrophel and Stella*, sonnets 1,70,93. Ovid (*Amores*, III.12) is modernised by Thomas Heywood in *Troia Britannica* (London, 1609), pp.172-73: 'What neede you far for couloured unctions seeke,/When our blacke Ink can better paint thy cheeke.' Earlier, and in a non-literary context, Nicholas Sanders, *A Treatise of the Images of Christ* (Louvain, 1567), fol.58ʳ, argues that as men can read the Bible, why can they not be allowed to see the Bible's visions 'on the Church wall, as in white paper?'. The widespread habit in prefaces of the period of referring to Apelles' and Zeuxis' *trompes l'œil*, which seem in the spectators' eyes to be alive, surely springs in part from the writers' acknowledgement that their pictures, that is, books, only come alive in their readers' eyes. [79]Whetstone, *An Heptameron*, sig. Mivʳ. Other remarks in the period suggest that the Elizabethans were prepared to believe that a spectator could be deceived by a painted image into thinking it was real; for example, Haydocke, *Tracte*, Preface, sig. ¶ iiiᵛ. It is hard to known whether these remarks are simply an adaptation of Pliny, or a record of fact.

the story of Zeuxis deceived by the work of Parrhasius,[80] such a response was not to be despised. The spectator's share could also be more sophisticated, a more subtle appreciation of painting or sculpture. The shift towards 'There might you see' — a typical 1590s phrase to be found in poems by Shakespeare, Marlowe and Drayton, for example — invites the audience's participation, giving us a more active part, so that we actually contribute to the illusion of what is described.[81] Drayton's account of the painted chamber devised by the queen of Edward II for Mortimer is surely more lively in the 1596 version, *Mortimeriados*, than in the 1603, *The Barons Warres*,[82] which, though more informed and connoisseur-like, simply tells us what to see without inviting our participation in creating the marvels of the painted chamber, or, in other words, creating the miraculous illusion which is really the writer's, not the painter's.

The invitation to the reader to behold is also a sign of the writers' growing awareness that it was the way one looked at a thing that shaped its meaning. I would not claim that pictorial illusion brought sixteenth-century English writers to an awareness of the relativism of meaning. But, to quote an opinion (derived from Aristotle) which met with agreement, 'there is nothing in the understanding, which was not first in the sense [of sight]': their first-hand discovery that a painting could yield one way a distortion, another way a well-proportioned image of a young prince,[83] depending on the angle from which one looked at it, must have brought home in a very vivid way the importance of the subjective viewpoint.

Both the lifelikeness formulae inevitably tend to encourage hyperbole:

> A thousand lamentable objects there,
> In scorn of nature, art gave lifeless life.[84]

Or, from the fifth stanza of Chapman's *Ovids Banquet of Sence*, the strange statues of the children of Niobe, with

> lookes so deadly sad, so lively doone,
> As if Death liv'd in theyr confusion.

[80]*Naturall Historie*, II, 535. [81]The concept of the beholder's share comes from E.H. Gombrich, *Art and Illusion*, pp.205 ff. Theatre-illusion as a phenomenon which is incomplete without the beholder's share has recently been discussed by R.A. Foakes, ' "Forms to His Conceit": Shakespeare and the Uses of Stage-Illusion', British Academy Annual Shakespeare Lecture, April 1980 (to be printed in *Proceedings of the British Academy*). [82]Canto VI, ll.233-344, in *Works*, II, 110-14; commentary V, 68. [83]A well-known example is William Scrots's anamorphic portrait of Edward VI, now in the National Portrait Gallery (Strong, *The English Icon*, p.70). Aristotle's opinion is quoted by Lomazzo; Haydocke, *Tracte*, 5, 180. Compare Daniel's preface to *The Woorthy Tract of Paulus Jovius* (1585). [84]*Lucrece*, ll.1373-74.

Such hyperbole is not, I think, simply a by-product of the exaggeration associated with Petrarchism. Although the late sixteenth century liked to use audacious hyperbole on every possible occasion, that ubiquitous taste does not sufficiently explain the hyperbolic praise of pictures. For the taste for pictures does not spring from hyperbole; and that same taste is inseparable from the aura of extreme lifelikeness which, in the eyes of the English spectator of the late sixteenth century, surrounded the picture that skilfully used the devices of shadows and perspective.

Hyperbole of the sort used to praise painting was particularly valuable to the poet who loved his art and wished to advance its, and his own, status. The poet, for example, extolling his mistress's coral lips, sun-like eyes and so forth, was obviously the infatuated lover (or pretending to be), whereas in praising a painting he had, psychologically at least, a more objective role. His linguistic superlatives, and the eloquence they led to, represented something projected outwardly by the imagination rather than dwelt on by the fantasy (how far can we trust the picture of the mistress which is graven in the poet-lover's heart?).[85] The idea of the lifelike pictorial artefact stimulated the writer to display an invention and artistry to match, a mechanism that is encapsulated in Angel Daye's account of descriptive epistles.[86] In these, he says,

> the excellencie of the writer, and paynter concurreth in one, who the more that eche of them studieth by perfection, to touche all thinges to the quicke, by so much the more nearer doe they both aspire, to that exquisite kind of cunning, that in eche of these differences, is absolutely to be required.

Daye is obviously talking about the writer's and the painter's ability to reach the essence — as it were — of their subjects. He then extols the curious painter's 'perfect peece of *Lantskip*',

> wherein seemeth the delight so rare, and climate so perfect, as verye desire provoketh a man to gaze on it, as a thing in present life, and most certaine viewe. And doe I pray you, our excellent writers degenerate at all from any part of these?

The passage shows in miniature how the imagination's rights in literature were won in part by the eye. The 'perfect peece' spurred the writer on to bring into existence a world that had no existence before, a world to image God's great poem the world,[87] a microcosm that was powered by the energy of hyperbole coupled with the energy provided

[85]This commonplace of the English sonneteer is set in its European perspective by L.C. John, *The Elizabethan Sonnet Sequences* (New York, 1938), pp.100 ff. [86]*The English Secretorie*, p.44. [87]*Davideis*, in *The English Writings of Abraham Cowley*, edited by A.R. Waller, 2 vols (Cambridge, 1905), I, 253: '*Gods Poem*, this *Worlds* new *Essay*'.

by illusion. The rival artefact therefore provided a singularly creative impulse.

It is on the nature and legacy of that illusion that I should like to end this essay. Sir Henry Wotton in his *Elements of Architecture* (1624) says that a fine picture comes near to being an *'Artificall Miracle'*.[88] His phrase, and the gist of the accompanying definition of painting — as an art that can 'make diverse distinct *Eminences* appear upon a *Flat*, by force of *Shadowes*, and yet the *Shadowes* themselves not to appeare' — is a comment on the miraculous illusion and sense of reality that a good Renaissance picture can achieve. However, the *'Artificiall Miracle'* for the Elizabethans and early Jacobeans has a special character, because where we see naturalism in the lifelikeness produced by perspective and chiaroscuro, they saw deception. To Hilliard, for example, perspective is an art whose effect is 'to deseave both the understanding and the eye'. Such a point of view explains why Hakewill speaks of painting as a kind of 'artificiall deceiving of the eie', and says that the sense of sight 'is so bewitched that its then most delighted, when tis most deceived, by shadowings, and landskips, and in mistaking counterfeits for truths'; or why Norgate calls landscape 'nothing but Deceptive visions, a kind of cousning or cheating of your owne Eyes, by your own consent and assistance'. To borrow from a recent study of Inigo Jones's masques, 'the "realness" of perspective lay less in its naturalism than in its power to project something that was recognised to be an illusion'.[89] 'We take pleasure in the lye,' says Ben Jonson, 'and are glad, wee can cousen ourselves.'[90]

The reaction of the English belongs to a wider European sensibility, associated with Baroque painting, and summed up, in a more sophisticated form, by Bernini's criticism of the wall-decorations in the apartments of Pope Alexander VI: 'They appear to be what they are whereas they should appear to be what they are not.'[91] The point, though, about the English recognition of the illusionist nature of certain sorts of painting is not so much that it echoes a European model, as that it opened up a world of wonder for the English writer to exploit, which he plentifully did.

For we do not actually cozen ourselves into mistaking either the picture or the poem — or the play — for reality. What develops in the

[88]*Elements*, p.83, in the context of a brief picture and sculpture paragone. [89]Orgel and Strong, I, 11. [90]*Discoveries*, in *Works*, VIII, 607. His immediate source seems to be Vives, *De Anima*, (Basle, 1538) Book III, p.205, 'De Offensione': 'Mendacio omnes offendimur, siquidem narretur tanquam verum. alioqui autem delectat compositio & assimulatio veritatis: ut pictura, vel imitatio inimica'. [91]*Filippo Baldinucci's Vita des Gio.Lorenzo Bernini*, edited by A. Reigl (Vienna, 1912), p.239. Bernini called them 'poco artifiziosi, perchè essendo quasi di tutto rilievo, parevano quello, che erano, e non quello, che non erano', quoted by A. Blunt in his Creighton Lecture of November 1976, on illusionism in Baroque painting, sculpture and architecture. The view perhaps connects with the idea expressed in Lomazzo, that mediocre painting appears more

spectator's eye is wonder; as a seventeenth-century writer says, both poetry and painting

> doe wind themselves by an unsensible delight of admiration so closely into our hearts, that they make us in such an astonishment of wonder to stare upon the Imitation of things naturall, as if we saw the true things themselves.[92]

Such wonder enables the writer to develop a kind of synaesthesia between art and life, postponing the moment when one admits, in Jonson's words, that 'likenesse is alwayes on this side Truth'.[93] Rabelais parodied the rapturous accounts of amazingly lifelike artefacts in the *Hypnerotomachia*, tacitly accusing the author of creating a sterile desert of self-regarding artifice.[94] But English Renaissance writers at their best use admiration begotten by illusion to enhance the reader's sense of what life is capable of. This is true of whole poems that are, in a sense, powered by their admiration for and identification with amazing works of art, such as the most successful of the Ovidian narratives, *Hero and Leander*, *Venus and Adonis* and *Lucrece*. It is also true of passages that conjure up amazing works of art, such as those of the Bowre of Blis, and the House of Busyrane, in *The Faerie Queene*, seen through the eyes of a Guyon, or a Britomart, bringing to life physical, moral and emotional worlds that we scarcely dreamt of.[95]

Nor is the fruitfulness of pictorial artifice limited to poems, for the *'Artificiall Miracle'* leads to remarkable effects in drama, especially in Shakespeare's plays, enabling him both to reflect on the nature of his own illusory art and to highlight a moment in which human emotion is felt with more than usual reality, and mystery.[96] This is hinted at as early as 1600 through the living artefact of the masque of Hymen at the end of *As You Like It*, which, for spectators on and off stage, momentarily replaces the familiar world of love lived with through five acts.

Some eight years later, *Antony and Cleopatra*, although it does not hinge on any masque, statue or picture, exploits continually the reaction of near-simultaneous wonder and consciousness of deception

'pinte che finte', 'rather *painted*, than *counterfeited*' (Lomazzo, *Trattato* (1844), I, 406; Haydocke, *Tracte*, 4,168). For a placing of Shakespeare in the context of European Baroque art, see Nicholas Brooke, 'Shakespeare and Baroque Art', *Proceedings of the British Academy*, 63 (1977), 53-69. [92]Francis Junius, *The Painting of the Ancients*, p.54. [93]*Discoveries*, in *Works*, VIII, 590. [94]Book V of *Gargantua and Pantagruel*, ch.31,38. [95]II, 12; III,13. [96]The argument for the value of picture to drama asks to be extended to Webster's *The Duchess of Malfi* (1613), with its highly pictorial contrasts of dark and light creating a nightmarish 'reality' which is actually highly ambiguous. The play's relation to perspective-pictures has been explored by I-S. Ewbank. 'Webster's Realism or, "A cunning piece wrought perspective"', in *John Webster*, edited by Brian Morris (London, 1970), pp.157-78.

that is formulated by one's response to an illusionist painting. It is a play of virtuoso pictorial effects in virtuoso poetry, such as Antony's 'wide arch of the ranged empire', the vision of Cleopatra on the river Cydnus, and Cleopatra's dream of Antony.[97] All defy the scale and intensity of normal life, and to each of them a character on stage responds, so that our sense of being invited to participate in creating an illusion is sharpened. Not that the characters on stage are all cozened by the lies offered them. 'Excellent falsehood', says Cleopatra to Antony's grandiose hyperbole. 'Gentle madam, no', says Dolabella to Cleopatra's question, 'Think you there was, or might be, such a man/As this I dream'd of?. And Agrippa, who accepts Enobarbus' picture of Cleopatra, is scarcely a judge to rely on.

The mode of the play is 'There might you see.' Twice we are told by means of pictorial effects that we have to make a choice of how to see Antony; once by Cleopatra, comparing him to a perspective-picture, one way a Gorgon, the other way a Mars, and the second time by Antony himself, as he describes changing pictures in the clouds:

> My good knave, Eros, now thy captain is
> Even such a body: here I am Antony;
> Yet cannot hold this visible shape.[98]

The acute sense of choice, and of not knowing how to choose, is continually forced on the spectator, who on the one hand connives with Shakespeare's hyperbole, because of the delight which the duplicitous rhetoric offers, and on the other cannot ignore another judgement presented him by more or less judicious spectators in the play, such as Demetrius and Philo, Dolabella and Enobarbus.

The play ends with Cleopatra's suicide. What is, metaphorically speaking, her statue, robed, crowned and enthroned, is a token of the power of art to make a living fame — and in a double sense. By her final transformation Cleopatra defeats Octavius Caesar who must concede his intended triumph in Rome, with Cleopatra as its *pièce de résistance*, to Cleopatra's own triumph; while it is Shakespeare's dramatic and verbal art that mendaciously presents a truth, the fact that she and Antony have acquired fame.

However, it is in the last plays where miraculous art does most. As in *Antony and Cleopatra*, Shakespeare makes us spectators of spectators, increasing enormously our awareness of illusion; but whereas in *Antony and Cleopatra*, the artifice is displayed in verbal pictures seen with the mind's eye — all but the final spectacle of Cleopatra's triumph in death — in *The Winter's Tale* and *The Tempest* it is realised in living works of art side-by-side with their actor-creators. Was it perhaps the

[97]I.1.33-34; II.2.199-226; V.2.76-100. [98]II.5.116-17; IV.12.2-14.

effectiveness of a transformation from life to death cast in a very statuesque form in *Antony and Cleopatra* which gave Shakespeare a hint of what he might achieve dramatically by presenting a transformation, in sculptural terms, from death to life in *The Winter's Tale?*

In that play, only the first audience would fully have believed that Hermione was dead, but though an audience today inevitably knows that she has not died, Shakespeare's failure to let us into Paulina's secret until the very last scene means we can share the stage-spectators' amazement, helping create the wonder out of which artist and audience bring alive the work of art. 'It is requir'd/You do awake your faith'; such is the condition for the Pygmalion-miracle.[99] That Hermione appears as a statue increases the emotional power of the scene in several ways. The onlookers dwell, naturally enough, on the verisimilitude of the 'statue':

> See my Lord,
> Would you not deem it breath'd and that those veins,
> Did verily bear blood?
> — Masterly done!
> The very life seems warm upon her lip.
> — The fixture of her eye has motion in't.
> As we are mocked with art.

An amazingly lifelike work of art, quite apart from what it represents, moves the heart because of the skill it displays;[100] this compounds and intensifies the emotion the stage-spectators feel at being reminded of Hermione. Their response to her, and through it ours, goes therefore beyond anything that a straightforward stage-entry could achieve. Further, the 'statue' creates a moment into which 'all the motives, all the interests and effects of a long history, have condensed themselves, and which seems to absorb past and present in an intense consciousness of the present'.[101] Such mastery over time is extraordinarily apposite in a play which depends so much on *veritas filia temporis*. Time has to reveal the truth of Hermione's fidelity and the true ancestry of her daughter; but Shakespeare has transformed the aphorism which was appended to his source, Greene's *Pandosto*. The true Hermione, truly loved, comes to life as the result of time as concentrated by the artist into the *trompe l'œil* of the statue.[102]

The time-arresting moment has, for the theatre audience, the practical function of preventing speculation about what Hermione has

[99]V.3.94-95. [100]This kind of response is discussed by the Abbé Du Bos, *Réflexions critiques sur la poésie et sur la peinture*, 2 vols (Paris, 1719), I, 64-65. [101]Walter Pater, 'The School of Giorgione', in *The Renaissance* (London, 1873), p.150. [102]S. Iwasaki, '"Veritas Filia Temporis" and Shakespeare', *English Literary Renaissance*, 3 (1973), 249-63, associates Hermione with the phrase *veritas filia temporis*, but without mentioning this dimension of the idea.

been doing in the interval of sixteen years since her supposed death. It also abstracts us from the sort of feeling that is merely experienced as habit, returning us (and Leontes) to human affection with something like astonishment, creating a fresh recognition of the nature of being human. Such a shock of recognition is more important in *The Winter's Tale* than it would be in the comedies, since the later play avoids a happy-ever-after air to its ending, instead leaving the audience with the feeling that human affairs will, by and large, continue to show the patterns of fortune and misfortune, innocence and corruption, that we have already seen.

Whether in poetry or drama, the power of the picture to intensify the emotion and the moment in which it is felt is a major reason for its adoption by the writer. The emotion may be love, as in *The Winter's Tale* and *The Tempest*, grief, as in *Lucrece,* or fascinated fear, as in Britomart's vision of the sights of the House of Busyrane. The painted chamber of *Mortimeriados* (and the later version of *The Barons Warres*) is not only created on the orders of the infatuated Queen, but comes to be seen as the counterpart of the love between her and Mortimer.

Where the emotion is love, it is as though the lover, through his super-active vision, looks at the world and beholds it glowing with more than usual beauty and reality. This is, of course, a *sine qua non* of dream-vision. What has happened in English poetry around 1600 is that the vision has become part of a waking world, perhaps partly through the agency of Colonna's *Hypnerotomachia* of 1499 which, as well as appearing in the relatively accessible French translation of the mid-sixteenth century, was translated in part as *The strife of Love in a Dreame* in 1592. The Italian dream-vision tells the story of Polia's lover's dream largely through a series of descriptions of amazing works of art; and in *The strife of Love in a Dreame,* the descriptions occupy a far greater part than the lover's accounts of his unhappy love. It perhaps helped confirm, in a quasi-literary form, the excitement and potential for the artist in visual appearances; it certainly exalted the artist's power.

For, far more than with pre-Renaissance dream-vision, the excellent work of art in the poem, or the play, keeps us aware of the artist who has produced it, and actually encourages us to reflect on the means by which the miracle is achieved. Marlowe, for instance, gives *Hero and Leander* a strong sensation of more-than-lifelike reality which is accompanied by an equally strong awareness that the poet *is* practising an enchanting deception, and at the same time actually inviting us to look at how it is done. We are not like the birds who flew to the painted grapes or even Zeuxis trying to raise the painted curtain, though we can see how we might almost be; we know that it is the result of someone's imagination and art (whether that person is Marlowe, or a

character in a play, such as Paulina).

The simultaneous knowledge of *is* and *seems* produced by the pictorial work of art (or its evocation) overrides the sense of time produced by habit that consists only of past and future, since the excellent picture pre-eminently exists above and beyond a day-to-day time sequence, instead pausing over, or rather shaping, one significant moment. Hence why it is so peculiarly congenial to the Elizabethans with their highly developed sensitivity to the mutable; and hence why the picture's shadows, its distillation of appearance and reality, are separable from the dramatist's shadows, and indeed, desirable to the dramatist. The nightmare feeling of 'nothing is but what is not'[103] stems from bewilderment of the sight, the vertiginous split-second when an 'enchanting deception' has prised apart things as they look from things as they are. It is ironic but vastly appropriate that when Hazlitt describes the effect of a fine gallery of pictures, he combines his own words with those of Macbeth: 'Everything seems "palpable to feeling as to sight". Substances turn to shadows . . . shadows harden into substances. "The eye is made the fool of the other senses, or else worth all the rest".'[104]

Perhaps then picture's greatest legacy to poetry, dramatic and otherwise, in the decades on either side of 1600 is its capacity to create at one and the same moment the equipollent illusions of *is* and *is not;* for this is precisely the sense of human life as something that is both shadow and substance which literature of the time brings alive so remarkably vividly.

[103]*Macbeth*, I.3.141. [104]*Sketches of the Principal Picture-Galleries in England*, pp.29-30, quoting *Macbeth*, II.1.44-45.

Appendix

Books on art, perspective and architecture in English Renaissance libraries 1580–1630

Picture-poetry relationships are notoriously hard to make precise. As ballast, therefore, to an essay which is of necessity partly speculative, there follows a survey of an area which can to some extent be documented, and which throws some light on English knowledge of Renaissance and Mannerist visual art *c.*1580-1630: that is, books in England on the subject. Such a review can suggest what treatises were available in England, and therefore what discourse on the arts Englishmen had access to, other than those two influential discussions, Castiglione's in Book I of *The Courtier* and Agrippa's (perhaps even more widely read) in *Of the Vanitie and uncertaintie of Artes and Sciences* (English translation, 1569). A survey can demonstrate what illustrations Englishmen could have seen; it can also, as will be shown, illuminate some of their ways of thinking about the visual arts.

It is in the period 1580-1610 that one discovers the greatest contradiction between the writers' high praise of pictorial art and, in general, a relatively low standard of the representational arts available to them, and when there is the biggest question mark over what was known of the visual arts; accordingly, the search has centred on this period. Originally I looked for treatises on pictures, but extended boundaries to take in treatises on perspective and architecture, up to the publication date of 1616 (the date of the edition of Palladio given to Jesus College, Oxford, by Robert Fludd). Perspective is an obvious topic to include since it is a part of the Renaissance painter's art; also if perspective treatises are not uncommon after 1580 in English libraries — as indeed turns out to be the case — the fact adds support to the argument put forward in Chapter II above that perspective impinged quite dramatically on Englishmen's ideas towards the end of the sixteenth century. Architecture is a less obvious candidate, though at least one English book-owner put it in the same bracket as 'Pictura',[1] and indeed Vitruvius had argued that all the visual arts

[1] Unknown owner, Northamptonshire Record Office, Finch-Hatton MS 4025, fol.3r. Compare Hakewill, *An Apologie* (1627), p.266: 'Such is the *affinitie* betwixt the *arts* of *painting & building,* by reason they both stand chiefly upon *proportion & just dimensions,* that *Vassari* . . . hath likewise written the lives of the most famous & best skilled in both.'

shared the common fountain of drawing. They also had a common interest in perspective, and other premises about art, such as the importance of proportion, and of the artist's concept or idea, so that their ownership indicates possible familiarity with certain current ideas on art theory. And, like the works on perspective, they sometimes contain handsome illustrations which are as much pictorial as technical.[2]

Defining the limits of 'books on the visual arts' does, however, present something of a problem.[3] I have omitted treatises on fortification, military architecture, and surveying, since literature is my *point d'appui* and the writers do not show an interest in these spheres, though the illustrations to some surveying treatises probably had a bearing on the dissemination of knowledge of landscape-engravings in England.[4] I have also omitted the following categories: works purely on the image controversy following the Council of Trent, such as Paleotti's *De imaginibus sacris et profanis* (Ingolstadt, 1594);[5] books on emblems and imprese, such as Valeriano's very popular work, the *Hieroglyphica*; and guide-books on Italy and the Low Countries, although I shall have a word to say about these.

Information about the distribution and ownership of books on the visual arts can come from varying sources. Surviving copies are perhaps the most obvious of these, and an example from my own experience of the kind of evidence that can turn up in this way is Sir Nicholas Throckmorton's gift of a copy of Jean Cousin's *Livre de perspective* to William Cecil in 1561.[6] This is significant because Throckmorton (1515-77) was English ambassador in Paris at the time; his interests, combined with those of Sir Thomas Smith who from 1562 shared the ambassadorship with him, must have done much to spread knowledge of recent treatises on architecture and perspective in England. Two other examples of such evidence that I have come across are Thomas Brett's gift of a copy of Lomazzo to Haydocke,[7] and

[2]Illustrations have recently been reviewed by Wynne Jeudwine, *Art and Style in Printed Books: Six Centuries of Typography, I: the Fifteenth and Sixteenth Centuries* (London, 1979). [3]Schlosser's *La letteratura artistica,* translated by F. Rossi, 2nd edition with additions by O. Kurz (Florence and Vienna, 1956), is indispensable. [4]See above, ch.II, note 83. On the importance of surveying to the development of linear perspective, see Kim Veltman, 'Renaissance Optics and Perspective: a Study in the Problems of Size and Distance' (unpublished Ph.D. thesis, University of London, 1975). And for the record, Robert Cecil and Northumberland both owned copies of Jacques Perret's *Des fortifications et artifices architecture et perspective* (Paris, 1601), which is as much on civil architecture as fortification. Sir Thomas Tresham owned numbers of books on surveying and fortification. [5]Of which Haydocke gave a copy to the Bodleian in 1601. [6]The volume was subsequently acquired by George Abbot (1562-1633), Archbishop of Canterbury, but is unmentioned in the shelf-list of his books, presumably because it was already bound up with Ducerceau's *Architecture* (Paris, 1582). It is now in Lambeth Palace Library. [7]See my note 'Haydocke's Copy of Lomazzo's *Trattato', The Library,* 6th series, 1 (1979), 76-81.

the surviving books of Sir Thomas Brudenell (1578-1663), son-in-law of Sir Thomas Tresham, who was interested in architecture.[8] A systematic review of all copies of Haydocke's translation of Lomazzo's *Trattato* has to some extent been done by Alastair Moffat.[9]

Other kinds of information include borrowings and references. Examples of the first are the lines of *Astrophel and Stella*, sonnet 7, derived from Alberti's *De pictura*, and the passage from E.K.'s preface to Spenser's *Shepheardes Calender* based on Paolo Pino's *Dialogo di pittura* (see above, Chapter II, pp.25-26). Sometimes particular treatises are referred to: Northumberland's letter of 1610 to Sir John Holles, and Holles's reply, name several;[10] Peacham mentions the location of two copies of Vasari's *Vite*, and states that he has used Carel Van Mander's *Schilderboek* (Alkmaar, 1604), although no book-list of the period that I have seen mentions that work; Hilliard, and Haydocke, refer to Armenini's *De'veri precetti della pittura* (Ravenna, 1587);[11] William Burton, Robert Burton's brother, refers (rather cryptically in some cases) to works on the arts that he has seen, or heard about.[12]

However, lists and catalogues of the period yield the most information, and they form the basis of the evidence presented here, although they pose many problems.[13] For instance, it would not have been satisfactory to examine only lists which can be dated between 1580 and 1610, for the simple reason that a copy of a book may have been in England long before it was catalogued in, say, the 1620s or 1630s. The question of where to draw the line in the seventeenth century is complicated by the fact that both catalogues and art treatises in them proliferate as the century advances. The possession of books becomes more widespread, to name one factor. Another is that the example set by the Bodleian Library in starting a Benefactors' Register was followed by numerous Oxford and Cambridge colleges. I have therefore closed my search at a slightly later date than strictly necessary, around 1630. Such a date, as well as enabling one to pick up

[8]A number of books that can be identified as having belonged to Sir Thomas Brudenell are still in the library at Deene Park. [9]In 'Lomazzo's Treatises', pp.53-54 and note 48. [10]HMC Report on Portland Manuscripts, 10 vols (London, 1891-1931), IX, 152, and BL, Additional MS 32464, fols 39ᵛ-40ʳ. [11]Discussed by J. Pope-Hennessy, 'Nicholas Hilliard and Mannerist Art Theory', *JWCI*, 6 (1943), 89-100, who also suggests (p.90) that the 'other' art treatises Hilliard refers to are those by Possevino, and Gallucci's translation of Dürer's *Vier Bücher* (Venice, 1591 and 1594). He further points out some parallels between Hilliard's remarks and Van Mander's *Lehrgedicht* (completed by 1597). [12]Quoted by Nichols, *The History and Antiquities of Leicester*, III, 489-90. Writing of his youthful interest in pictures, Burton speaks of a number of writers on art including 'Georgio Vasari Aretino', the author of the lives of the Italian painters. This could imply a memory of Dolce's *L'Aretino*. The other authors Burton mentions are Leonardo, Dürer, Jost Amman and an unidentifiable 'Gualterio Florentius, who hath also written the lives of the chiefest painters in Italy'. [13]My enquiry would not have been feasible without Sears Jayne's *Library Catalogues of the English Renaissance* (Berkeley and Los Angeles, 1956).

books which may have been in England some years earlier, also shows the beginning of a contrast between the years around 1600 and the position developing in England later in the century, when interest in the visual arts clearly becomes much more extensive, and the cult of the virtuoso develops.[14] The books known to have belonged to Inigo Jones have been included, although some of them may have been acquired quite late in the century, since he is such a pivotal figure for the visual arts in England.[15] As regards the Bodleian Library, the date of the first printed catalogue, 1605, has been chosen as the terminus, since comparison with the 1620 catalogue shows that the Bodleian's acquisitions of books on the visual arts between 1605 and 1620 were negligible.[16]

The main problem in using library catalogues of the period as a research tool is that few of them are known relative to the number of book-collections that must have existed. Many collections are known only by tantalising references, such as that of Sir William Pickering who in 1574 willed that neither his armory 'nor my Liberarye be spoiled nor dispersed',[17] or that of Dr Mountford in 1622, referred to by Peacham.[18]

Such lists as we have may not, for the most part, be the significant ones, either because they represent only books in a certain category (such as, 'my masters books Caryed with him to Eaton')[19] or because they indicate the books of men who were not especially interested in art and/or architecture. In the present survey, for example, less than half of the catalogues and lists consulted — more than fifty — contained any mention of books on the visual arts and architecture. Very few lists of art-lovers' books are known.[20] Those that Sir Henry Wotton owned can only be inferred from his own writings. And surely that eager collector of old master paintings, Lucy, Countess of Bedford (the daughter of Sir John Harington), who competed with

[14]The sharpest contrast would be with the books of John Evelyn. See Christie's sale catalogues for 22-23 June, 30 November and 1 December 1977; 15-16 March and 12-13 July 1978. The standard article on the cult of the virtuoso is that by Walter E. Houghton, Jr., *JHI*, 3(1942), 51-73 and 190-219. [15]See above, ch.II, note 42. [16]The Bodleian's relatively extensive holdings of books on art and architecture by 1605 are likely to have been due to Haydocke's interests; he may have helped Sir Thomas Bodley (A. Moffat, 'Lomazzo's Treatises', ch.1). Other tastes probably contributed, such as Thomas Allen's and that of Sir Thomas Bodley himself. It is noticeable that George Hakewill, a kinsman of Bodley's, is interested in the visual arts. [17]J.W. Burgon, *Life and Times of Sir Thomas Gresham*, 2 vols (London, 1839), II, 460. The point about Sir William's library is that it passed to his daughter, who married Sir Edward Wotton, so that Pickering's books formed part of the library at Boughton-Malherb, in Kent (the home of the Wottons), till it was dispersed in 1630. [18]*The Compleat Gentleman* (London, 1622), p.137. [19]Some of Sir John Harington's books: BL, Additional MS 27632, fol.11[v]. [20]Disappointingly, recent work on Gabriel Harvey's books has failed to reveal any on the visual arts; see Virginia Stern, *Gabriel Harvey: His Life, Marginalia and Books* (Oxford, 1979).

Arundel to lay hands on works by Holbein,[21] must have owned more
books on art and architecture than those included in her gift of 1628 to
Sidney Sussex College, Cambridge?

One tantalising lacuna is the library of printed books belonging to
Thomas Allen, mathematician and fellow of Gloucester Hall, Oxford,
friend of Northumberland, and of students of the arts such as
Haydocke, whose first copy of the *Trattato* came from Allen. Allen's
books passed to Sir Kenelm Digby, who in a letter speaks of having a
list made by Bodley's Librarian, but such a list, if ever carried out, has
not survived or at least not been found.[22] Allen is just the sort of
scholar about whose books on art and architecture one would like
some information. As a mathematician he would have been interested
in painting because it used perspective, if for no other reason, and
therefore would have been relatively free of the many prejudices
against painting which, for one reason and another, influenced many
Englishmen.

Another hindrance offered by catalogues and lists is that they
frequently lack detail, or the right sort of detail. Which edition of
Alberti's treatise on building is represented by 'Architectura fol'?
What are Knyvett's two treatises described as 'The art of drawing in
ducth [Dutch]', and 'Perspective in duch. fol'?[23] Which work in a 1614
list of Robert Cecil's books is indicated by 'Perspective R. Cotton in fol
(given to my Lo. Arundell)'? Only rarely does a surviving volume
allow such ambiguity to be resolved.

Benefactors' Books of Oxford and Cambridge college libraries are,
in a specialised search such as this, of limited use only, because a man's
gift of books to a college was not usually a cross-section of his interests,
and he may not have felt that books to do with art and architecture
showed him in the most dignified light. Thus, Sir Thomas Tresham's
gifts of books to St John's College, Oxford, made in 1598, 1599 and in
the next few years, do not even hint at the interest in architecture and
perspective which is proven by his building enterprises and by the
catalogue of his own library.[24]

[21] *The Private Correspondence of Jane Lady Cornwallis, 1613-1644*, pp.50-51.
[22] Kenelm Digby, *Private Memoirs*, [edited by Sir Nicholas Harris Nicholas] (London,
1827), pp.xlvii-xlviii, printed from BL, Cotton Vespasian MS F.XIII, fol.330r. See also
L. Delisle, 'Sir Kenelm Digby and the Ancient Relations Between the French Libraries
and Great Britain', *The Library*, 2nd series, 5 (1893), 1-15. Even the latest research on
Allen's manuscripts turns up no information on his printed books; see Andrew Watson,
'Thomas Allen of Oxford and His Manuscripts', in *Medieval Scribes, Manuscripts &
Libraries: Essays Presented to N.R.Ker*, edited by M.B. Parkes and Andrew Watson
(London, 1978), pp.279-314. [23] The English practice of sometimes translating
'Deutsch' as 'Dutch' does not help. [24] See N.R. Ker, 'Oxford College Libraries in the
Sixteenth Century', *BLR*, 6 (1959), 459-515 (p.511); and John Fuggles, 'A History of
the Library of St John's College, Oxford from the Foundation of the College to 1660'
(unpublished B. Litt. thesis, University of Oxford, 1975), whose help on Laud's gifts to

The chief caveat about the number and distribution of copies of treatises that can be deduced from catalogues is that the information they yield does not accurately reflect the actual numbers and kinds of such books in England in the period. In the first place, more copies of the treatises must have been around than can be traced today. If, for example, five copies of Cousin's *Livre de perspective* can easily be tracked down, most likely more copies were around in England; such works were not necessarily in circulation only among well-known names, for gifts of treatises recorded in the Bodleian Benefactors' Register by no means always come from predictable or likely donors. In the second place, that a book does not figure in any of the extant lists (or at any rate those examined) does not mean that it was not known in England. Thus, no list mentions the works of Pino and Van Mander, although both were used by English writers. Even works published in England are not necessarily to be found mentioned in catalogues; examples are Robert Peake's translation of Serlio from the Dutch, (London, 1611), and *The booke of five collumnes of architecture, gathered by H. Bloome* (London, 1608), although Sir John Summerson points out that the original of the latter was in use in England by 1570.[25]

A further obvious limitation of book lists is that they give virtually no idea of a book's circulation, although there is evidence to show that books were lent, whether housed in the remote library of a country gentleman or in the larger centres of population.[26]

Altogether, therefore, this survey is only a pilot-study; its use is to suggest a bare minimum of titles and of copies to be found in England for the period 1580-1630, and the frequency of such works relative to each other. Yet even a survey of such limited scope reveals how many more such books were to be found in England than has been thought to be the case. Perhaps chief of the omissions it has been able to rectify is that relating to Sir Thomas Tresham's books on architecture and perspective. Sir Thomas's library catalogue (in the British Library) was unaccountably unidentified by Sears Jayne, and overlooked by Eric Mercer, who described Tresham as not revealing 'any knowledge of or interest in the books and buildings that the greater men were

the college has been most useful. A factor certainly at St John's College was that the college itself told benefactors what books and sorts of books it wished to acquire.
[25]*Architecture in Britain* pp.55-56. English translation by I.T., *STC* 3162. See also J. Summerson, 'The Book of Architecture of John Thorpe', *Walpole Society*, 40 (1966).
[26]Sir Robert Cotton's practice of lending books is the best-known; see Kevin Sharpe, *Sir Robert Cotton 1586-1631: History and Politics in Early Modern Britain* (Oxford, 1979), ch.2. Perhaps architectural treatises were particularly likely to be circulated — Northumberland's to Sir John Holles, and so forth. D.J. McKitterick, *The Library of Sir Thomas Knyvett* (Cambridge, 1978), p.22, discusses some of the links that a country house library might possess; Henry Peacham, for example, was for a time Master at Wymondham School, only three miles from Ashwellthorpe, Knyvett's home.

building'.[27] Sir Thomas's books on this area are, on the contrary, the most extensive collection that I have come across. They will doubtless yield more sources of his own building projects and operations; for example, to take a slightly unorthodox approach, views from ground level of the roof-ridges and triangular chimney of the triangular lodge at Rushton can look disconcertingly reminiscent of perspective diagrams in the treatises.

A brief résumé of findings is perhaps appropriate as a supplement to the lists which come below. To start with the first printed Renaissance treatise on painting, Alberti's in its Latin or its Italian form is found separately published in only two catalogues of the period that I have seen (Dee's and Lumley's); but as the Italian translation was included in an edition of his *Architettura*, it therefore appears in one other. And as we have seen, Sidney borrowed from it. Probably several more copies were around, and certainly more can be traced later in the seventeenth century.[28]

Vasari's *Vite* is much rarer, appearing in Dee's catalogue, and, thanks to Haydocke's gift of 1601, in the Bodleian 1605 catalogue. In the mid seventeenth century the Bodleian Library received another copy from Selden's library. Peacham refers to Vasari in his *Compleat Gentleman*, but confirms that the book was hard to find in England. As late as 1622 he says that he knows of only two copies in London, those belonging to Inigo Jones, and to Dr Mountford.[29] The latter is Thomas Mountford, Prebendary of Westminster, who died February 1632/3, a slightly surprising figure to have had such a book in his library. Edward Norgate, whose *Miniatura* his editor dates to *c*. 1621-26, was obviously familiar with the *Vite*, quoting Vasari on a number of occasions,[30] and George Hakewill refers to Vasari, though whether at first or second hand one cannot be sure.[31]

Other mid and late sixteenth-century discourses on painting and pictures were obviously extremely rare. E.K.'s borrowing from Pino's *Dialogo* was based on a passage also used by Philip Du Plessis Mornay, in *De la vérité de la religion Chrestienne* (Antwerp, 1581), as part of a defence of mountains.[32] That work cannot have been E.K.'s

[27]*English Art 1553-1625*, p.58. Some of Sir Thomas Tresham's books are still in the library at Deene Park; unfortunately, only two architectural books still there can be identified as his, Jean Martin's translation of Vitruvius (Paris, 1547), and Guidobaldo del Monte's *Perspectivae libri vi* (Pesaro, 1600). [28]The 1734 catalogue of the Middle Temple Library also records a copy (Basle, 1540), one of a small group of early editions of books on the visual arts still in the library. *La pittura* was also, like his treatise on sculpture, included in Alberti's *Opuscoli morali*, translated and corrected by C. Bartoli (Venice, 1568). I have not checked for copies of this edition. [29]*The Compleat Gentleman*, p.137. [30]*Miniatura*, p.79, for example. [31]*An Apologie* (Oxford, 1627), p.266. [32]Pino's passage, in the context of art history, is discussed by E.H. Gombrich, *Norm and Form*, pp.107-21. In *De la vérité* the passage occurs on p.238, translated by Philip Sidney and Arthur Golding as *A Woorke concerning the trewnesse of*

source since it was published two years after *The Shepheardes Calender*, but as Mornay himself was in England in the late 1570s, and visited Sidney, it is possible that he brought a copy of the *Dialogo* with him, which passed around the Sidney circle.[33]

While other titles by Lodovico Dolce and Anton-Francesco Doni can be found in England in the period under discussion, I have not been able to trace copies of their books touching on painting, except for Doni's *I Marmi*, which is mentioned by Florio as a book consulted, in 1598, and of which the Bodleian Library and Sir Thomas Knyvett owned copies.[34] The Bodleian also possessed Benedetto Varchi's *Lezioni* by 1605.[35] Dolce's *L'Aretino* I have not been able to find mentioned in England in this period.

Giovanni Battista Armenini's *De'veri precetti della pittura*, used by Hilliard in his treatise on limning, was perhaps known to the English painter through Haydocke, who also refers to it.[36] Ben Jonson's remarks on picture in his *Discoveries* seem, on the face of it, to be based on Armenini. However, his source is actually Possevino's *De poësi et pictura* which uses Armenini, and which, from 1593, was included in editions of Possevino's *Biblioteca selecta*, a selection of the best authorities to study on the arts and the sciences.[37] Jonson may have been interested in pictures, but his allusions to them in *Discoveries* have no more to do with any direct experience of painting than his picture poems.[38]

Lomazzo's *Trattato* was obviously hard to obtain in England. Haydocke recounts his difficulties: first Thomas Allen found him a copy, damaged by shipwreck, and then another friend, whom we now know to have been Thomas Brett of All Souls College, presented him with a satisfactory copy. Perhaps this was the one which Haydocke gave to the Bodleian in 1601, although the 1605 catalogue mentions Lomazzo only in Haydocke's translation.[39] As for this 1598 translation, at least thirty copies are known to be in existence today although it figures in few early seventeenth-century lists, a discrepancy

the *Christian Religion* (London, 1587), p.177. [33]Buxton, *Sir Philip Sidney and the English Renaissance*, p.93. [34]It is interesting that Angel Daye in the 1595 edition of his *English Secretorie*, p.135, adapts one of Doni's devices, showing Truth burning a mask, Doni's motto offering a play on Daye's name: 'Quel che molestava accendo et ardo.' Alas for any theory that Daye had a special link with Italy, the woodcut is the same as that used in Sir Thomas North's *The Morall Philosophie of Doni* (London, 1579), whence, presumably, Daye took it. [35]The *Lezioni* of 1590 included the *Due Lezione* (1549), one of which was a paragone between painting and sculpture. [36]See note 11 above. [37]*Discoveries*, in *Works*, VIII, 609-12; see IX, 259-60. [38]*Works*, VIII, 272-81, for example. Such (implied) paragoni seem to lead into the 'advice-to-the-painter' class of poem; see M.T. Osborne, *Advice-to-a-Painter Poems 1633-1856* (Austin, 1949). [39]Brett's copy (BL, 561*.a.1(1)) has an old press-mark on the title-page, 7.Z.6 [?], a three-symbol variety which is found throughout Europe but is not a Bodleian Library type. I am grateful to Mr Paul Morgan of the Bodleian Library for this information.

which should warn us against taking too literally any numerical count arising from this survey.[40]

Perspective treatises figure far more frequently in book lists than those on pictures, a fact which is not surprising since perspective served many practical functions in building, fortification and surveying, as well as being dignified by its close association with mathematics. Nevertheless, that a book such as Cousin's on perspective, which went through only the one edition in 1560, should have found its way into five collections noted in this survey, is remarkable. Also unexpected is the fact that Guidobaldo del Monte's *Perspectivae libri vi* (Pesaro, 1600) should have entered English libraries so quickly; four copies have been noted. Their incidence presumably reflects the relatively advanced state of studies in mathematics in early seventeenth-century England.[41]

The class of treatise to be found most frequently is, as one might expect of men who had a passion for building, that on architecture.[42] Those of Alberti, Serlio and Palladio would look quite common, were copies of Vitruvius not so ubiquitous; using library lists alone, about thirty-seven copies can be found, by comparison with about thirteen of Alberti's work on building. Yet though the presence of fairly large numbers of building and architecture treatises is predictable, to enumerate all the copies mentioned in catalogues is to gain the impression of an England possessing more contact with European theory than is usually assumed.

Finally, copies of Dürer's *Geometria* and *Symmetria,* in one or other of the several translations and editions, are quite widely distributed, and all the evidence suggests that they were relatively well known in England, undoubtedly helping to account for Dürer's high reputation as an artist;[43] for in England to be in print was, despite gentlemanly qualms about the stigma of print, indispensable for reputation (thus references to Aretino's pornographic pictures, that is Giulio Romano's illustrations to the *Sonetti lussuriosi,* are quite frequent although it is very doubtful whether Marston, Donne, Peacham and young men about Cambridge had actually seen them). The *Geometria* is the one treatise on the arts included in Robert Burton's bequests of books to

[40]See A. Moffat, 'Lomazzo's Treatises', pp.53-54 and note 48. [41]See, for example, the discussion in *Thomas Harriot,* edited by J.W. Shirley (Oxford, 1974), ch.1 and 4. [42]For the architectural context see Summerson, *Architecture in Britain,* ch. 2-4; M. Girouard, *Robert Smythson and the Architecture of the Elizabethan Era* (London, 1966); J.A. Gotch, *Early Renaissance Architecture in England* (London, 1901). M.P. Caldwell's 'Sir Henry Wotton: Aspects of English Taste in the Early Seventeenth Century' (unpublished M.Phil. thesis, University of London, 1975) is also very useful. [43]He is mentioned by, among others, Bacon, Dee, Hilliard, Haydocke, Peacham and Donne. Hakewill in praising him mentions Erasmus's eulogy of him (see the article by Panofsky, cited above ch.II, note 124). His name even finds a place in English drama: 'Alberdure' in *The Wisdom of Dr Dodypoll,* see above, ch.III, p.42.

the Bodleian and Christ Church.[44] So much, then, for the impression given by *The Anatomy of Melancholy* (Part 2, sect.2, memb.4.), where Burton, by the time of the fourth edition, talks with an easy familiarity about painters and painting.

As several of the treatises on perspective and architecture possessed handsome cuts or engravings — such as those specially prepared for Cousin's *Perspective,* or the more modest ones from various sources used by Rivius in the *Vitruvius Teutsch* (Nuremberg, 1548), and his *Architectura* (Nuremberg, 1547)[45] — the question arises of what these may have contributed to the Englishman's sense of pictorial art. What did the owners and borrowers of Cousin's treatise make of the splendid design on sig. Aii[r] (Plate 5) which more than any 'perspective-picture' demonstrates the art of perspective?[46] There is no evidence that the English were aware of book-illustrations as works of art. They no more comment directly on the plates in the treatises than they do on the illustrations to Colonna's *Hypnerotomachia,* several copies of which can be traced in England by 1620;[47] and the crude wood-cuts to the part-translation of it, *The strife of Love in a Dreame* (London, 1592), are a silent testimony to at least some men's insensitivity to the beautiful originals. However, the illustrations to the treatises, since they were in circulation, cannot have been ignored, and of course the treatises were a kind of pattern-book for the English builders.

Several of the treatises on perspective also contain remarks on contemporary painting, but I have come across no evidence that they were noticed or used by English writers. So it seems that such material was available in England but encapsulated either in the libraries of country gentlemen and builders, or — less obviously but more insidiously — by a frame of reference with which the English were unfamiliar.

Books on architecture were expensive; it is understandable that they do not figure in the book-lists of, say, university men, as seen in Oxford inventories, 1550-1650.[48] However, two books appear with remarkable frequency in libraries of the period; these are Lodovico Guicciardini's *Descrittione . . . di tutti i paesi bassi* (Antwerp, 1567 and later editions), and Leandro Alberti's *Descrittione di tutta Italia* (Bologna, 1550 and later editions). From these, had he wished, the Englishman could have learnt a lot about European painters and painting. Guicciardini includes a long section on the Netherlandish painters and engravers, which was separately translated and published in England in the eighteenth century;[49] the Elizabethan epitomiser of

[44]See 'List of Burton's Library', edited by S. Gibson and F.R.D. Needham, *OBS,* 1(1925), 222-46. [45]On Rivius's illustrations, see Jeudwyne, *Art and Style,* p.457 and references therein. [46]See above, ch.II, p.25. [47]For example, Knyvett owned one of the French editions, as well as the (unillustrated) 1545 edition. [48]Transcription by Mr W. Mitchell, in the Bodleian Library. [49]As *Guicciardini's Account of the Ancient*

the work in the 1590s entirely omits this, as though his reader will only be interested in trade figures.[50] Leandro Alberti often includes comments on the artists of each city and their works. Such easily available information seems to have been entirely ignored by the Elizabethan, although he would readily quote a classical writer on a classical artist. By contrast, much of Robert Burton's apparently wide acquaintance with Italian painting and near-contemporary art, set out in successive editions of *The Anatomy of Melancholy*, not only must have come from books, but from the many guidebooks in his library.

The reasons why the sixteenth-century reader turned a blind eye, so to speak, are various. The climate of iconoclasm led to a distrust of, and a lack of interest in, painting and sculpture to be found in Europe, and the Englishman simply did not have the direct experience of pictures which would have made the remarks of Lodovico Guicciardini or Leandro Alberti meaningful. Pliny, by contrast, or even L-B. Alberti — or even, much later, Possevino — offered comments on painters in a framework that was in some respects familiar and accessible to the Elizabethans.[51] Another reason is that, at least up to 1600 in England, contemporary painting and sculpture did not constitute a category of knowledge, and were far from achieving the respectable status of a liberal science, far less a liberal art.[52] English library categories of the Renaissance do not have a place for the representational arts.[53] Tresham's library for example, and it is typical, has sections on theology, history, philosophy, rhetoric, grammar, politics, mathematics, and letter-writing. Had fifteenth- and sixteenth-century European painting fitted into one of these, Englishmen would have been more intellectually receptive to it, and more prepared to buy works on it. Sir Edward Coke owned copies of Barbaro's *La pratica della perspettiva*, and Boccaccio's *Genealogia deorum*. The second could be assimilated, under 'Approved Histories'. Barbaro's treatise was placed under 'Tracts & discourses'. If he found difficulty in assigning a place to a perspective treatise, how much more troublesome Vasari's *Vite* would have been. Coke's categories are idiosyncratic, for most Elizabethans and Jacobeans include treatises

Flemish School of Painting (London, 1795). [50]The Elizabethan version was by T. Danett, *The description of the Low Countreys and of the provinces thereof, gathered into an epitome out of the Historie of L. Guicchardini* (London, 1593). [51]On the importance of the frame of reference, see C.E. Gilbert, 'Antique Frameworks for Renaissance Art Theory: Alberti and Pino', *Marsyas*, 3(1943-45), 87-106. An interesting example of how men adapted old categories is provided by Pomponio Gauricus, who 'assimilates perspective . . . to the *perspicuitas* of Quintilian': R. Klein in *Pomponio Gauricus, 'De Sculptura'(1504)*, edited and translated by A. Chastel and Robert Klein (Geneva, 1969), p.177. [52]See N. Pevsner, *Academies of Art Past and Present* (Cambridge, 1940), ch.2; also P.O. Kristeller, 'The Modern System of the Arts', *JHI*, 12 (1951), 496-527, and 13 (1952), 17-46. [53]One catalogue I have looked at has a small section on architecture and picture: Finch-Hatton MS 4025.

on architecture and perspective under mathematics.[54] But where, for example, was Lomazzo to go? In 1617, the cataloguer of William, fourth Baron Paget's library solved the problem by putting Haydocke's translation under mathematics, along with a very respectable collection of works on perspective, architecture and proportion, but it was plainly not a satisfactory answer if Lomazzo's treatise were viewed as one on *art*.

The apparently trivial point of library categories has far-reaching implications. Pliny, the art-historian of the ancients, was an authority to be respected and followed; Vasari, the art-historian of the moderns, fitting in nowhere, was not. The more a writer on painting used a frame of reference based on the classics — or was set in such a context, as Dürer was by Erasmus — the more accessible and desirable he was to the English reader. The two kinds of contemporary painting which the English undoubtedly comment on because they were struck by what they saw were the anamorphosis or 'perspective-picture', and landscape. Providentially, Pliny had provided a precedent for admiring *trompe l'œil* paintings, and landscapes, as well as a way of talking about them. Anamorphoses and landscapes could therefore quite easily be assimilated to Englishmen's thinking about pictures. Vasari offered to the English reader a new way of placing paintings, assuming an experience of pictures which the English did not possess, and based on the subtle concept of *disegno*, design and drawing, which as we have seen in Chapter II above was lacking in England until several years into the seventeenth century (to take an optimistic view of its advent).[55] Thus Vasari was virtually without influence in England around 1600.

In the third edition of *The Anatomy of Melancholy* (Oxford, 1628), Robert Burton writes:

> To most kinde of men it is an extraordinary delight to study. For what a world of bookes offers it selfe, in all subjects, arts, and sciences, to the sweete content and capacity of the Reader? In *Arithmeticke, Geometry, Perspective, Opticke, Astronomy, Architecture, Mechanicks* and their misteries.

In the fourth edition (Oxford, 1632), his list of subjects has developed as follows:

> 'In *Arithmeticke, Geometry, Perspective, Opticke, Astronomie, Architecture, Sculpturâ, Picturâ*, of which so many and such elaborate Treatises are of late written'.[56]

[54]The Bodleian is avant-garde in its 1605 catalogue in putting art and architectural books under *Artium*. [55]See above, ch.II, pp.8-14 and 36, note 135. [56]Part 2, sect.2, memb.4.

The date at which he makes this change can also stand as a sign of when the English begin to accept books on the pictorial arts as normal inhabitants of a library, and when the fine arts in England take their place among the Liberal Sciences.

Book catalogues and collections

The following list is, with two exceptions, based on book catalogues; the exceptions are Northumberland's letter to Sir John Holles of 1610, and Inigo Jones's surviving books on the visual arts. Each catalogue mentioned below is followed by an abbreviation, which is used in showing the distribution of treatises in the subsequent list of such books. It should be noted that the date of a catalogue, for example Tresham's of 1605, simply indicates the last possible date of entries in that catalogue, which may contain earlier lists and books possessed by the owner long before.

The Bodleian Benefactors' Register I have used firstly as a complement to the 1605 printed catalogue, when it shows that a particular book had been given to the Bodleian by 1605, even though it appears not to have been incorporated into the library by that date; and secondly, to discover, where possible, the donor of a particular book. I have relegated to footnotes books on art and architecture bequeathed by Lord Herbert of Cherbury to Jesus College, Oxford, 1648, by Laud to St John's College, Oxford, after 1630, and by Selden to the Bodleian Library, 1659, since they fall too late in the century, and in a sense belong to a different climate where the fine arts are concerned.[57]

The following groups of books are still to be found at their old locations: Abbot's at Lambeth Palace; the Countess of Bedford's gift to Sidney Sussex College, Cambridge, at that college; Robert Cecil's at Hatfield; the books on architecture at Corpus Christi College, Oxford; Fludd's copy of Palladio at Jesus College, Oxford; Laud's (and Paddy's) gifts of books on art and architecture at St John's College, Oxford. The location of other individual copies, where known, is

[57]Lord Herbert's gift is described by C.J. Fordyce and T.M. Knox, 'The Library of Jesus College, Oxford', *OBS*, 5 (1936-1940), 49-115 (pp.71ff). Laud's gifts to St John's College, Oxford are recorded in the Benefactors' Register of that college, although the dates assigned are unreliable; see J. Fuggles, 'A History of the Library of St John's College, Oxford', pp.139ff. Selden's books are indicated in Thomas Hyde's 1674 catalogue of the Bodleian Library.

indicated by footnotes keyed to the list of treatises. The numbers following each catalogue refer to the treatises to be found in that particular collection of books.

Abbot, George (1562-1633). Undated shelf-list; Lambeth Palace Library, Library Records 3-4.[58] (Abbot) 12. 15. 31(2).

Bedford, Lucy, Countess of (d.1627). Sidney Sussex College, Cambridge, Donors' Book, pp.21-30. (Bedford) 9. 26. 37(2).

Bodleian Library, Oxford. Thomas James, *Catalogus librorum bibliothecæ publicae quam. . . Thomas Bodleius. . . instituit* (Oxford, 1605). (Bodleian) 2(2). 3. 5. 6. 11. 12. 13. 14. 17. 23. 24. 25. 26. 27. 29. 31. 33. 34. 35. 37(2). 38.

Bodleian Library, Oxford, Benefactors' Register.[59] (Bodl.BR) 4. 22. 36. 37. 39.

Cambridge University Library. Shelf-list by John Frickley (1582). Cambridge University Registry, MS 30.1.item 10. (CUL 1582) 17.

Cecil, Robert, first Earl of Salisbury (1563?-1612). 1614 catalogue, Hatfield House archives.[60] (Cecil) 10. 16. 37(3).

Coke, Sir Edward (1552-1634). *A Catalogue of the Library of Sir Edward Coke*, edited by W.O. Hassall, Yale Law Library Publications 12 (New Haven, 1950). (Coke) 3(2).

Corpus Christi College, Oxford. J.R. Liddell, 'The Library of Corpus Christi College, Oxford, in the Sixteenth Century', *The Library*, 4th series, 18 (1937-38), 385-416. (CCCO) 2. 37(2).

Dee, John (1527-1608). Catalogue of 1583, BL, MS Harley 1879, fols 20r-108r.[61] (Dee) 1. 2(2). 3. 6. 7. 12. 17. 18(2). 19. 21. 25. 28. 35. 37(5).

Fludd, Robert (1574-1637). Gift to Jesus College, Oxford, 1630. Benefactors' Book. (Fludd) 26.

Florio, John. List of books consulted, at the end of *A Worlde of Wordes* (London, 1598). (Florio) 34.

[58]The Bancroft-Abbot catalogues are discussed by Ann Cox-Johnson, 'Lambeth Palace Library 1610-1664', *Transactions of the Cambridge Bibliographical Society*, 2 (1955), 105-26. [59]Some donors gave books, some gave money; see W.D. Macray, *Annals of the Bodleian Library, Oxford*, 2nd edition (Oxford, 1890). Donors' names have been mentioned only when they clearly gave printed books. [60]The Hatfield House archives are cited by kind permission of The Marquess of Salisbury. The book-list there dated 1568 does not contain any books on the visual arts, though Burghley's interest in architecture is well known. The books in the sale catalogue of 1687 (Wing B 5726), advertised as those of William Cecil, almost certainly had nothing to do with him. Mr Harcourt Williams, archivist to Hatfield House, suggests they came from the Exeter side of the family. [61]Earlier catalogues of Dee's library exist, notably that of around 1556 (BL, Additional MS 35213, fols1r-4r). For a description of Dee's library, see Frances Yates, *Theatre of the World* (London, 1969), ch.1 and 2, and forthcoming volume by Julian Roberts and Andrew Watson, *John Dee's Library Catalogue*. Dr Yates (pp.35-36) points out that Dee also possessed a copy of Silvio Belli's *Della proportione e proportionalità* (1573).

Holles, Sir John (1564?-1637). Letter of ninth Earl of Northumberland to, 1610, HMC Report on Portland Manuscripts, IX, 152. (Holes) 26.

Jones, Inigo (1573-1652). Books owned by him listed in John Harris, Stephen Orgel and Roy Strong, *The King's Arcadia: Inigo Jones and the Stuart Court* (London, 1973), pp.63-67 and Appendix 3. (Jones) 1. 2. 5. 9. 22. 24. 26. 29. 30. 31. 35. 37.

Jonson, Ben. *Works* (1952), XI, 599-600. (Jonson) 37(2).

Knyvett, Sir Thomas (*c.*1539-1618). Catalogue of 1608, Cambridge University Library, MS Ff.2.30; D.J. McKitterick, *The Library of Sir Thomas Knyvett of Ashwellthorpe c.1539-1618* (Cambridge, 1978). (Knyvett) 2. 3. 6. 9. 12. 14. 18. 21. 24. 26. 31(2). 37(2).

Lake, Arthur (1569-1626). 1617 gift to New College, Oxford; Library Benefaction Book, pp.53-64. (Lake) ?22.

Lumley, John, Lord (*c.*1534-1609). *The Lumley Library: the Catalogue of 1609,* edited by Sears Jayne and Francis R. Johnson (London, 1956). (Lumley) 1. 19. 37(2).

Northumberland, Henry Percy, ninth Earl of (1564-1632). Letter of 1610, in HMC Report on Portland Manuscripts, IX, 152; G.R. Batho, 'The Library of the "Wizard" Earl', *The Library*, 5th series, 15 (1960), 246-61. (Northumberland) 2. 5. 10. 13. 15(2?). 24(2). 26. 31. 33. 37. 38. 39.

Paget, William, fourth Baron (1572-1629). Library catalogue of 1617; BL, MS Harley 3267. (Paget) 2(2). 22. 23. 25. 29. 30. 32. 37(3).

St John's College, Cambridge. Class catalogue of *c.*2,100 printed books, in Cambridge University Library, MS Dd. 5.45 (*c.*1631). (SJCC) 23.

St John's College, Oxford. Benefactors' Register, entries up to William Laud's donations. (SJCO) 2.

Smith, Sir Thomas (1513-1577). List of 406 books which on 1 August 1566, were in the gallery at Hill Hall.[62] J. Strype, *Life of Sir Thomas Smith* (Oxford, 1820), pp.274-81. (Smith) 18. 37(5).

Tresham, Sir Thomas (1543?-1605). List *c.*1605 of 2,600 manuscripts and printed books; BL, Additional MS 39830, fols 155[v]-214[r].[63] (Tresham) 2. 3. 5. 6. 8. 9. 12. 15. 18(2). 20. 23. 24. 26. 31(3?). 32. 37(6). 38(2).

Unknown owner. Northamptonshire Record Office, Finch-Hatton MS 4025.[64] (Finch-Hatton) 2.[65] 37(2).

[62]On Sir Thomas Smith's Hill Hall, see N. Pevsner's article 'Hill Hall', *Architectural Review*, 124 (1955), 307. [63]The main shelf-lists appear on fol. 164[v] and, repeated with more information, fol.191[v]. There are also references to architectural books on fols 204[r], 205[v], 211[r], 213[v]. [64]This manuscript is one of a very mixed group, from the Earls of Winchelsea and Nottingham. Some of the manuscripts derive from the Finch family of Eastwell, Kent, and some from the family to which Sir Christopher Hatton belonged. The daughter of Sir William Finch of Eastwell in Kent was the mother of Sir Henry Wotton. [65]The collection also contains a manuscript of Alberti's *Architettura*.

Treatises

1[66] Alberti, Leon-Battista. *De pictura* (Basle, 1540): Dee[67]
 La pittura, translated by L. Domenichi
 (Venice, 1547): Lumley
 This translation included in *L'architettura et
 altri trattati*, translated by C. Bartoli
 (Monreale, 1565): Jones[68]

2[69] ——*De re aedificatoria* (Florence, 1485): CCCO[70]
 —— (Paris, 1512): Bodleian. North-
 umberland.[71] SJCO[72]
 L'architettura, translated by C. Bartoli
 (Florence, 1550): Bodleian. Knyvett[73]
 —— translated by C. Bartoli
 (Monreale, 1565): Jones[74]
 L'architecture, translated by J. Martin
 (Paris, 1553): Dee
 Unidentified editions: Dee ('de architectura
 Paris 1523' [for 1543?]).
 Tresham ('Ital'). Paget
 (2 copies, one Latin, the
 other 'L'Architecture y
 Alberti'). Finch-Hatton:
 Italian MS

3 Barbaro, Daniele. *La pratica della perspettiva* Dee. Bodleian. Tresham.
 (Venice, 1569): Knyvett. Coke (2)

4[75] Barozzi, Jacopo, called Vignola. *La due regole della* Bodl.BR (Wriothesley
 prospettiva practica, edited by E. Danti (Rome, gift of £100, 1605)
 1583 and later editions):

5[76] ——*Regole delli cinque ordini d'architettura*
 (Venice, 1582): Tresham
 —— (Venice, 1596): Bodleian
 —— (Rome, 1607): Jones
 Unidentified edition: Northumberland
 ('Vignola')

[66]Laud's gift to St John's College, Oxford (1642) included a copy in *L'architettura et altri trattati* (Monreale, 1565). Selden's copy, which went to the Bodleian, was the Amsterdam edition of 1649. The Middle Temple Library includes the Basle edition of 1540. [67]Now in the Middle Temple Library. [68]In Worcester College, Oxford. [69]Other copies recorded later: Selden's (Paris, 1512); Laud's gift to St John's College, Oxford, see note 66 above; Sion College, founded in 1630 (printed catalogue of 1650, under the name of John Spencer, librarian, based on a shelf-list of 1632), *L'architecture* (Paris, 1553); Middle Temple Library, *L'architettura*, translated by P. Lauro (Venice, 1546). [70]From the college's founder, Richard Fox (?1448-1528); formerly the property of John Shirwood (d. 1494), Bishop of Durham. See P.S. Allen, 'Bishop Shirwood of Durham and His Library', *EHR*, 25 (1910), 445-56. [71]At Petworth. [72]Given by Sir William Paddy. [73]In Cambridge University Library. [74]In Worcester College. Oxford. [75]Lord Herbert's gift to Jesus College, Oxford included Barozzi's *Prospettiva*, edited by E. Danti (Rome, 1611). [76]Another work included in Lord Herbert's gift

6 Bassi, Martino. *Disparieri in materia d'architettura e* Dee. Bodleian.
 prospettiva con pareri di eccellenti e famosi Tresham. Knyvett
 architetti, che li risolvono (Brescia, 1572):

7 Beham, Hans. *Das Kunst und Lehrbüchlein Malen* Dee ('libelli de arte
 (Frankfurt, 1546 and later editions): pingendi . . . germanice
 Nur.1528')[77]

8 Bullant, Jean. *Reigle générale d'architecture* (registré Tresham (described as
 Paris, 1563): Paris, 1562)

9 Cataneo, Pietro. *I quattro primi libri d'architettura* Tresham.[79] Knyvett.
 (Venice, 1554):[78] Bedford
 L'architettura (Venice, 1567): Jones[80]

10 Caus, Solomon de. *La perspective, avec la raison des* Northumberland.[81]
 ombres et miroirs (London, 1612): Cecil

11 Comanini, Gregorio. *Il Figino, overo del fine della* Bodleian
 pittura (Mantua, 1541):

12 Cousin, Jean. *Livre de perspective* (Paris, 1560): Dee. Bodleian. Tresham.
 Knyvett. Abbot[82]

13 Dietterlin, Wendel. *Architectura von Ausstheilung,* Bodleian (Nur.1598).
 Symmetrie und Proportion der fünff Seulen Northumberland
 (Nuremberg, 1593 and later editions):

14 Doni, Anton-Francesco. *I marmi* (Venice, 1552): Bodleian.[83] Knyvett[84]

15 Ducerceau, Jacques Androuet. Either *Livre* Tresham. Abbot (Paris
 d'architecture (Paris, 1559) or *Le second livre* 1582).[85] Northumberland
 d'architecture (Paris, 1561), or a later edition: (Paris 1582;[86] also
 another volume by
 Ducerceau, possibly no.
 16.)

16 ———*Le premier/second volume des plus excellents* Cecil
 bastiments de France (Paris, 1576):

(Arnheim, 1620). John Webb says that '*Barozzio* . . . indisputably is Sir *H. Wotton's* Author' *(A Vindication of Stone-Heng restored*, p.38). [77]In the Trinity College, Cambridge manuscript of Dee's library (MS O.4.20), the place and date are given as Frankfurt, 1565. Beham's *Dieses Büchlein zeyget an und lernet ein mass oder proporcion der Ross* was indeed published in Nuremberg, 1528. As is well-known, this latter work was used by Haydocke for some of his illustrations for the *Tracte;* see K. Höltgen, 'Richard Haydocke: Translator, Engraver, Physician', *The Library*, 5th series, 33 (1978), 15-32. [78]Another copy of this work, which is virtually an edition of Vitruvius, was given by Laud to St John's College, Oxford (gift of 1633). [79]Now in the Sir John Soane's Museum; bookplate of 1585. [80]In Worcester College, Oxford. [81]At Petworth. [82]Given by Sir Nicholas Throckmorton to William Cecil, 1561. See above, note 6. [83]Probably from Sir Michael Dormer, 1603. [84]In Cambridge University Library. [85]Copy (in Lambeth Palace Library) inscribed 'Henry Cobham'. [86]At Petworth.

17 Dürer, Albrecht.[87] *Elementa geometrica* (Paris, 1532 Dee. CUL 1582.
 and later editions): Bodleian

18 ———*De symmetria partium humanorum corporum* Dee (Nur.1534, and Paris
 (Nuremberg, 1528 and many later editions): 1557). Tresham (Latin
 and German 'Paris
 1554'; also edition of
 1557). Smith

 Quatuor libri geometriae. . . . De symmetria
 (Paris, 1535): Knyvett[88]

19 Gauricus, Pomponio. *De sculptura* (Florence, 1504 Dee (Nur.,1542?).[89]
 and many later editions): Lumley (Antwerp 1528)

20 Labacco, Antonio. *Libro appartenente all' architettura* Tresham (1577)
 (Rome, 1552 and later editions):

21 Lencker, Hans. *Perspectiva* (Nuremberg, 1567 and Dee. Knyvett (Nur.1567)
 later editions):

22 Lomazzo, Giampaolo. *Trattato dell'arte de la pittura* Bodl. BR (Haydocke,
 (Milan, 1584): 1601). Jones[90]
 A tracte containing the artes of curious Paget. ?Lake ('The Arts
 paintinge carvinge & buildinge, translated by of Painting, Carving and
 R. Haydocke (Oxford, 1958): building')

23 Monte, Guidobaldo del. *Perspectivae libri vi* (Pesaro, Bodleian. Tresham.[91]
 1600): Paget. SJCC

24 L'Orme, Philibert de. *Le premier tome de* Tresham. Knyvett.[92]
 l'architecture (Paris, 1568): Jones[93]
 Unnamed or later editions: Northumberland ('Phili-
 bert de l'Orme'). Bodleian
 ('de l'Architect. 1576')

 Nouvelles inventions pour bien bastir Northumberland ('Phili-
 (Paris,1576):[94] bert de l'Orme *pour bastir*
 a petit frais')

25 Pacioli, Luca. *De divine proportione* (Venice, 1509): Dee. Bodleian. Paget

[87]In these English catalogues I have not come across the German versions of Dürer's works, that is, the *Unterweysung der Messung* (Nuremberg, 1525 and later editions), and *Vier Bücher von menschlicher Proportion* (Nuremberg, 1528 and many later editions and translations besides the Latin version); see Schlosser, *La letteratura artistica*. Some other copies of one or other of the Latin (and German) editions: Laud's gift of 1642 to St John's College, Oxford, included the *Institutia Geometria* (Arnheim, 1606), and *Opera* (Arnheim, 1603). Robert Burton's bequest to the Bodleian included a copy of the *Geometria* (see 'List of Burton's Library', edited by Gibson and Needham). [88]In Cambridge University Library. [89]In Cambridge University Library. [90]Collection Mr S. Sabin, London. [91]Not in the 1605 catalogue, but in the library at Deene Park. Bound, like the British Library copy, and that at University College, London, with *Mechanicorum Liber* (1577). [92]In Cambridge University Library. [93]In Worcester College, Oxford. [94]J.A. Gotch notes that Burghley requested a copy of this book from the English ambassador in Paris (*Early Renaissance Architecture in England*, p.261).

26 Palladio, Andrea. *I quattro libri dell'architettura* Tresham.[95] Knyvett[96]
 (Venice, 1570):
 ——— (Venice, 1601): Bodleian. Bedford.
 Northumberland.[97]
 Jones[98]
 ——— (Venice, 1616):[99] Fludd
 Unidentified edition: Holles

27 Possevino, Antonio. *Tractatio de poësi et pictura
 ethica* (Lyons, 1595):[100] Bodleian

28 Riff (or Ryff or Rivius), Gualterus Hermannus. *Der
 furnembsten, notwendigsten der gantzen
 Architectur angehörigen Mathematischen und
 Mechanischen künst* (Nuremberg, 1547): Dee

29 Rusconi, Giovanni Antonio. *Dell'architettura secondo* Bodleian. Paget.
 i precetti del Vitruvio, libri x (Venice, 1590): Jones

30 Scamozzi, Vincenzo. *Dell'idea dell'architettura* Paget. Jones[101]
 universale (Venice, 1615):

31 Serlio, Sebastiano.[102] *Il settimo libro d'architettura* Tresham (possibly two
 (Frankfurt, 1575): copies). Knyvett[103]
 De architectura, translated by C. Saraceni
 (Venice, 1569): Tresham. Knyvett
 Other editions: Abbot (translated by
 Martin, Paris 1545; also
 translated by Peter
 Coecke van Alst, 1542[104]).
 Bodleian (1545: Martin's
 translation?).[105] North-
 umberland
 Tutti l'opera d'architettura et prospetiva
 (Venice, c.1560-62): Jones[106]

32 Shute, John. *The first and chief groundes of* Tresham (1580). Paget
 architecture (London, 1563 and later editions):

[95]There is still a copy at Deene Park, but no evidence suggests that it was acquired by Sir Thomas Tresham. [96]In Cambridge University Library. [97]At Petworth. [98]In Worcester College, Oxford. [99]Lord Herbert's gift to Jesus College, Oxford included a copy. [100]First published in Rome, 1593. This work had a wide circulation, since it was included in Possevino's *Biblioteca selecta* in editions from 1593. [101]In Worcester College, Oxford. [102]Lord Herbert's bequest to Jesus College, Oxford included Peake's translation from the Dutch (London, 1611). There is also a copy of this at Deene Park. The Middle Temple Library includes *De architectura libri 5* (Venice, 1569); Mr Julian Roberts points out that some of the markings in it suggest it could once have belonged to John Dee. On editions of Serlio, see W.B. Dinsmoor, 'The Literary Remains of Sebastiano Serlio', *Art Bulletin*, 24 (1942), 55-91 and 116-54, which also contains a useful review of early publications on architecture in Italy. [103]In Cambridge University Library. [104]Not catalogued in the early shelf-list, but bound up with Martin's translation. [105]From Haydocke, 1601. [106]In Queen's College, Oxford.

33 Sirigatti, Lorenzo. *La pratica de prospettiva* Bodleian.
(Venice, 1596): Northumberland

34 Varchi, Benedetto. *Lezioni* (Florence, 1590). Bodleian. Florio

35 Vasari, Giorgio.[107] *Le vite de'piú eccellenti architetti,* Dee
pittori et scultori italiani* (Florence, 1550):
———— (Florence, 1568): Bodleian.[108] Jones[109]

36 Viator, or Jean Pelerin. *De artificiali perspectiva* Bodl.BR (Wriothesley
(Toulouse, 1505 and later editions; pirated gift of £100, 1605)
editions, Nuremberg, 1509 and 1540):[110]

37 Vitruvius.[111] *Identifiable editions.*
(Rome, n.d.) Sulpitius: CCCO[112]
(Venice, 1497) Giocondo: CCCO[113]
(Venice, 1511) Giocondo: Bedford
(Como, 1521) Cesariano: Cecil
(Florence, 1522) Giocondo: Dee[114]
(Venice, 1535) Durantino: Lumley[115]
(Perugia, 1536) Caporali: Tresham
(Paris, 1542) Sagredo, translated into French: Bodleian
(Strasbourg, 1543) Rivius: Dee
(Paris, 1545) Philander: Dee
(Paris, 1547) Martin: Tresham[116]
(Lyons, 1552) Philander: Lumley. Cecil
(Venice, 1557) Philander: Tresham. Knyvett
(Venice, 1567) Barbaro: Dee.[117] Tresham.
 Knyvett. Jonson.[118]

[107]Selden's copy went to the Bodleian (Florence, 1568). *Le vite* was one of the books bought by Sir Roger Pratt (1620-84) after January 1657 (Gunther, *The Architecture of Sir Robert Pratt*, p.6, also pp.284-304 for his views on architectural authorities and for his library). [108]From Haydocke, 1601. [109]In Worcester College, Oxford. [110]Used (in a pirated edition) by G. Reisch, *Margarita philosophica* (Strasbourg, 1512). [111]For a bibliography on Vitruvius, see B. Ebhardt, *Die Zehn Bücher der Architektur des Vitruv und ihre Herausgeber seit 1484* (Berlin, 1915). Copies of Vitruvius were far more numerous than is suggested by my entry, which does, however, suggest the wide range of editions to be found in England. Four copies of Giocondo's 1511 edition and nine of Barbaro's Latin edition of 1567 are to be found today in Cambridge alone (H.M. Adams, *Catalogue of Books Printed on the Continent of Europe 1501-1600 in Cambridge Libraries*, 2 vols (Cambridge, 1967), entries 902 and 909). Some other copies noted in England in the seventeenth century include the following: six given by Selden to the Bodleian, including Barbaro's Latin edition of 1567; Laud gave a copy of Barbaro's edition of Vitruvius, in Italian (Venice, 1584), to St John's College, Oxford, as well as a Latin manuscript. Several copies figure in the Benefactors' Register of Westminster Abbey Library, started by John Williams in the 1620s, who is said to have obtained the initial collection of books from 'that learned Gentleman Mr *Baker* of *Highgate';* John Hacket, *Scrinia reserata* (London, 1693), pp.46-47. [112]From the college's founder, Richard Fox; formerly the property of John Shirwood, Bishop of Durham (see above, note 70). [113]From John Claymond, president of Corpus Christi College, Oxford (d.1537). [114]Collection Mr W. Jeudwyne, London. [115]BL, 559*.d.8. [116]In Deene Park library. [117]In Chetham's Library, Manchester. [118]W.H. Robinson, Catalogue 71 (1940).

(Paris, 1572) Martin:
(Lyons, 1586) Philander:
Unidentified and undatable editions:

Paget. Bedford. Jones.[119]
Bodl.BR[120] (all the Latin editions)
Northumberland[121]
Jonson[122]
Dee (Martin, 'Paris 1553').
Bodleian ('Ital.cum. com.'). Smith (three in Latin;[123] one in Italian; one in French, probably Martin's translation). Tresham (two edited by Philander). Cecil ('given to my Lo: Arundell'). Finch-Hatton (one edited by Giocondo, one edited by Philander). Paget (Sagredo, translated into French (Paris, 1542 or 1550); also a Latin edition)

38 Vries, J. Vredeman de. *Architecture* (Antwerp, 1577):
———(the Hague, 1606):
Unidentified and doubtful:

Tresham. Bodleian
Northumberland[124]
Tresham ('Caryatid. . . vulgus term. . . vocat').
?Paget ('Hier. Cock. "Schemata Architecturæ"')

39 ——— *Perspective* (Leyden, 1599):

Bodl.BR (Wriothesley gift of £100, 1605).
Northumberland[125]

Unidentifiable treatises
'The art of drawing in ducth':
'Perspective R. Cotton in fol' (given to my Lo: Arundell)':
'Architectura de . . . columnarum . . . Argentinensum. fol':

Knyvett[126]

Cecil

Tresham (perhaps Rivius' Latin edition of Vitruvius (Strasbourg, 1543))

[119]At Chatsworth. [120]From Henry Stanford. 1600. [121]At Petworth. [122]C.K. Ogden, Orthological Institute. [123]One of these, 'Philonii Comment. in Architectur. Vitruvii', Nicholas Pevsner suggests could be an edition by Philander, whom Smith could have met; see 'Hill Hall', p.307. [124]At Petworth. [125]At Petworth. [126]McKitterick, *The Library of Sir Thomas Knyvett*, p.109, suggests this may have been the *Perspectiva* (Frankfurt, 1546) — woodcuts of interiors and costume — bound with Lencker's *Perspectiva* (Nuremberg, 1567), sold at Sotheby's 21 May 1862, Lot 1004.

Index

Entries in the right-hand column of the treatises list at the end of the Appendix are not indexed as these names can be found by referring to the preceding list of owners. Names in titles and of characters in plays and poems are also excluded.

Abbreviations

BL	British Library
BLR	*Bodleian Library Record*
BM	British Museum
c.	*circa*
d.	died
DNB	*Dictionary of National Biography*
EHR	*English Historical Review*
HMC	Historical Manuscripts Commission
JHI	*Journal of the History of Ideas*
JWCI	*Journal of the Warburg and Courtauld Institutes*
JWI	*Journal of the Warburg Institute*
memb.	member
n.d.	not dated
OBS	*Oxford Bibliographical Society*
sect.	section
sig.	signature
sigs	signatures
STC	*Short Title Catalogue of Books Printed in England. . . 1475-1640*, compiled by A.W. Pollard and G.R. Redgrave (London, 1946); 2nd edition revised, Vol.2 (London, 1976), compiled by W.A. Jackson, F.S. Ferguson and K.F. Pantzner
Wing	*Short Title Catalogue of Books Printed in England . . . 1641 – 1700,* compiled by Donald Wing, 3 vols (New York, 1945-51)

Dates in brackets after titles signify date of first publication.

i/j and **u/v** spellings are normalised to modern usage in quotations from early printed books.

[] denote editorial emendation and apparatus.

The abbreviation **ch.** followed by a roman numeral is used throughout for cross-references to chapters in this book, in order to distinguish them from chapter references to other works.

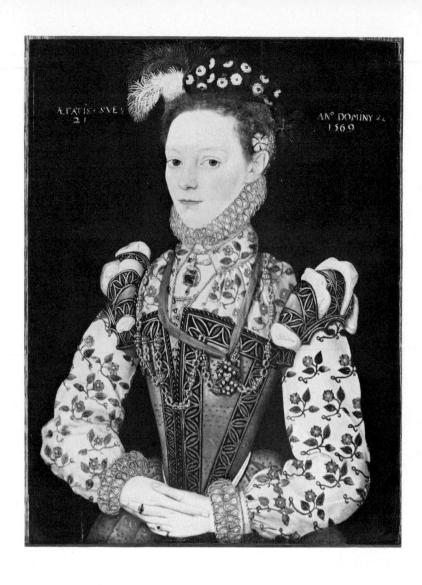

Plate 1 English School, *Portrait of a lady*; Tate Gallery, 629 × 483 mm.

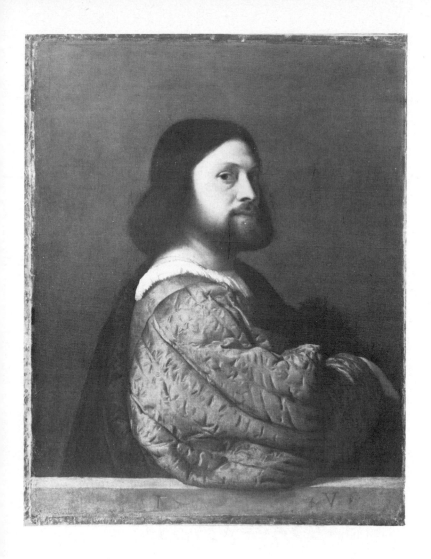

Plate 2 Titian, *Portrait of a man*; National Gallery, London, 812 × 663 mm.

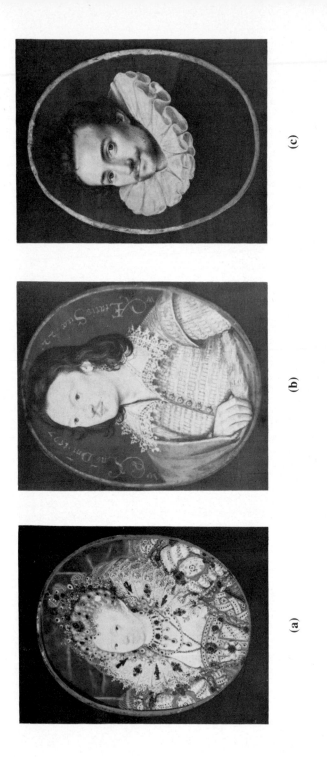

Plate 3 a) Nicholas Hilliard, *Miniature of Queen Elizabeth I*; Victoria and Albert Museum, 67 × 53.5 mm.
b) Nicholas Hilliard, *Portrait of a young man*; Victoria and Albert Museum, 51 × 28 mm.
c) Isaac Oliver, *Portrait of a young man*; Victoria and Albert Museum, 51 × 28 mm.

(a) (b) (c)

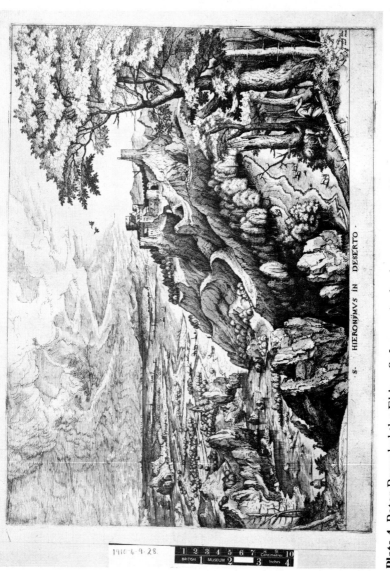

· S· HIERONYMVS IN DESERTO·

Plate 4 Peter Breughel the Elder, *St Jerome in the desert*, engraved by Hieronymus Cock; British Museum, 320 × 425 mm.

Plate 5 Jean Cousin, illustration of the five regular solids, sig. Aii^r of the *Livre de Perspective* (Paris, 1560), Lambeth Palace Library, 265 × 285 mm.

Notes to plates

Plate 1 English School, *Portrait of a lady*; Tate Gallery, T.400, (see Chapter II, p.21). This accomplished painting shows a distinctive English style in portraiture. Even later English portraits, such as those attributed to William Larkin (Strong, *The English Icon,* pp.316-24), tend to give first place to pattern, even though they make great play with objects which nominally create depth, such as carpets. The English taste for pattern seems to inform even the work of foreign painters in England, for example, Marcus Gheeraerts the Younger (see *The English Icon,* p.288, Plate 284).

Plate 2 Titian, *Portrait of a man;* National Gallery, London, no.1944. The dominant native tradition in England that gives such an important part to decorative and flat effects meant that works of art making the most of perspective and chiaroscuro to create the living presence of a sitter must have had a remarkable capacity to astound the spectator. This superb portrait by Titian shows the contrast with English portraiture very strongly, in terms of both depth and quality. The contrast is all the more striking in that Titian is just as fascinated by rich fabrics as an Elizabethan painter; but his treatment of the sitter's sleeve shows up light and dark, and volume, instead of decorative patterns. The portrait has a possible connection with seventeenth-century England, as it was conceivably once in the collection of Sir Anthony van Dyck.

Plate 3 **a**) Nicholas Hilliard, *Miniature of Queen Elizabeth I*; Victoria and Albert Museum, 622-1882 (see Chapter II, p.21). All portraiture of the Queen seems to fall within the traditional taste for predominantly flat paintings. Hilliard's miniature shows what that tradition can achieve at its best. The sitter is uniformly lit, and shadowing is minimal. Even the folds of the ruff, which appear to be minutely observed so as to give the impression of depth, are assimilated to a total effect of pattern.
b) Nicholas Hilliard, *Portrait of a young man* (1597); Victoria and Albert Museum, P.5-1944.
c) Isaac Oliver, *Portrait of a young man* (1590); Victoria and Albert Museum, P.50-1941 (see Chapter II, p.21).
These two miniatures are virtually contemporaneous; indeed,

we could be looking at the same sitter seen by two different artists. Oliver's miniature uses bold shadowing to give the portrait depth and solidity; it almost exemplifies the lavish degree of shadowing that Hilliard criticises in his treatise on limning.

Plate 4 Peter Breughel the Elder, *St Jerome in the desert,* engraved by Hieronymus Cock, *c.* 1550; BM, Prints and Drawings, 1910.4.9.28. Cock was a well-known and popular publisher of engravings, and there is no intrinsic reason why copies of such an engraving should not have appeared in London, particularly in the printing and stationers' world with which Angel Daye (see *DNB*) had close associations. Breughel's Alpine landscapes are especially marvellous examples of the genre, but work by lesser artists, such as a landscape illustrating some aspect of surveying, in an etching attributed to Jost Amman (BM, Prints and Drawings, 1952.4.5.209), also shows how impressive illusionist landscapes could look, all the more so when one contrasts them with the attractive but homely signs of landscape which illustrate Spenser's *Shepheardes Calender* (1579).

Plate 5 Jean Cousin, illustration of the five regular solids, sig. Aiir of the *Livre de perspective* (Paris, 1560). From the copy in Lambeth Palace Library, given to William Cecil by Sir Nicholas Throckmorton, 1561. (See Chapter II, p.25 and Appendix). This almost alarmingly illusionist construction appears in a treatise of which several copies can easily be traced in England soon after it was published. One cannot fail to be impressed by its deceptive plausibility, even if one does not know the technicalities of perspective; and as it occurs on the second page of the treatise, no reader could have overlooked it or missed the fact that 'perspective' was the name of the magical art. Other illustrations to the same work, such as the 'grand paisage' on sig. Miir also show impressively the power of perspective to create the illusion of depth and space.